THE SHINGLE STYLE TODAY

VINCENT SCULLY

THE SHINGLE STYLE TODAY

OR

THE HISTORIAN'S REVENGE

GEORGE BRAZILLER NEW YORK

For Louis I. Kahn

This is nothing until in a single man contained,
Nothing until this named thing nameless is
And is destroyed. . . .

Wallace Stevens, **Auroras of Autumn**

CONTENTS

PREFACE

This book was written and expanded (with the enormous assist-
ance of Helen Chillman in typing and illustration) from a
lecture I was honored to give at Columbia University in Septem-
ber, 1973. I am grateful to Dean James Polshek of Columbia's
distinguished School of Architecture for that opportunity, and
to Robert A. M. Stern for his generosity in making his slide
collection available to me.

One of the architects who heard the talk at Columbia
remarked that everybody mentioned favorably in it seemed to
be from, or to have at some time been intimately connected with,
Yale. This is true. The list (aside from Dean Polshek) would
include of the old Shingle Style architects none that I know of,
but of the new: Moore, Robertson, Stern, Hagmann, Israel,
Pasanella, Prentice, Brooks, Gwathmey (sorry, Charlie), Giurgola
and Venturi to some extent, and always in a special sense, Kahn.
Bloom, Wilson, and Cox must be claimed as well. Princeton,
Pennsylvania, and Columbia also figure a little but not, ever,
Harvard. I further venture to state that if the Yale School of
Architecture and its hitherto enlightened relation to the Human-
ities ever what you might call created anything, it is a good
part of the development which is happily (better a humble

arrogance than an arrogant humility, Wright used to say) described in this book.

It should also be noted that many of the architects mentioned have designed or, in their capacities as civil servants, have made possible the construction of some of the most distinguished public housing yet built in the United States. One thinks especially of Gio Pasanella's as yet inadequately appreciated achievements in the Bronx.

<div style="text-align: right">

Vincent Scully
Yale University
New Year's Eve, 1973

</div>

This book is about the influence of the Shingle Style of the 1880s on a number of American architects over the past fifteen years.* As such, it must recall the formal and spatial characteristics and the historical development of the first Shingle Style in order to assess the character and meaning of those contemporary forms which have in large measure derived from it. With these intentions, the present work cannot pretend to deal with the politics, planning, mass programs and pressures which create the man-made environment entire—which is what

* The essay will not be footnoted. I identified and named the Stick and Shingle Styles in my doctoral dissertation at Yale, *The Cottage Style*, of 1949, and published the material in my chapters "The Stick Style" and "The Shingle Style" in Antoinette F. Downing and Vincent J. Scully, Jr., *The Architectural Heritage of Newport, Rhode Island*, Cambridge, Mass., 1952, new edition, New York, 1969; and in my "Romantic Rationalism and the Expression of Structure in Wood: Downing, Wheeler, Gardner, and the 'Stick Style,' 1840–1876," *Art Bulletin*, 35 (1953), 121–142; and in "American Villas: Inventiveness in the American Suburb from Downing to Wright," *Architectural Review*, 115 (1954), 168–179; and in *The Shingle Style: Architectural Theory and Design from Richardson to the Origins of Wright*, New Haven, 1955; new edition (including the *Art Bulletin* article), *The Shingle Style with the Stick Style*, New Haven, 1971. The historical facts about the Shingle Style which are stated in this essay can be found in documented form in these works. Any references to Kahn's theory and work not illustrated here can be found in my *Louis I. Kahn*, New York, 1962. All quotations from Ralph Waldo Emerson are from his essay, *Nature*, of 1834.

architecture is eventually all about. But it is still concerned with something which has consistently remained of central importance in American architecture: the single-family house. In the United States such houses have been and, whether we like it or not, continue to be the major product of American building and a primary factor in the shaping of the American environment as a whole. That environmental dominance is one aspect of their formal and sociological importance; the other aspect is the intensely personal artistic immediacy which they embody. Like lyric poetry, single-family houses most openly mirror the character and feelings of their architects and so most directly reflect the influence of those architects upon each other. In them, history can be seen being made at individual heat, where new architects wrestle with their precursors in order to find a way to begin and room to operate for themselves.

Such interaction, as Harold Bloom has shown in his recent study of lyric poetry (*The Anxiety of Influence. A Theory of Poetry,* New York, 1973), is not without its anxieties. Artists are always uneasily aware of the lonely individual responsibility which somehow lies at the heart of all art-making, at least of all modern art, and for that reason among others they normally hate to admit to real influence from other artists. They will often eagerly acknowledge influences which were in fact of no importance to them—and precisely for that reason. Sometimes, like many contemporary architects, they may take refuge in the concept of team design. For all these reasons the historian is naive if he takes artists' statements about their influences, or even about their intentions, too much at face value. The truth must be read in their forms, and the facts of true influence can always be found there, where the strong young architect, no less than Bloom's "strong poet," inevitably fastens on the work of his chosen precursor, purposely "misreads" it, and finally "swerves" from it to create a new field of action for his own design. In fact, a study of the Shingle Style,

in relation to the work of the present generation of architects who have been influenced by it, indicates that it is the strongest among the latter who show its influence most directly. It is also the strongest who seem to have sought out the most force-ful of the precursor-architects to emulate and to outdo, and who have focused with what now begins to appear an almost fanatic intensity upon their strongest and most directly symbolic forms (Figs. 1,2).

In view of the fact that those forms became known to the modern generation through art-historical publication, another anxiety has arisen for the architect, involving his debt to the Liberal Arts. This, after a time, he is less anxious about acknowledging, since there is not quite the same kind of epic competition with another creative individual involved. Never-theless, the relationship does tend to upset him a little, because it runs counter to that contempt for the Liberal Arts, and for art history in particular, which characterized most American architects a generation ago. Such prejudices were partly derived from the iconoclasm of the imported neo-Bauhaus, but they were not without roots in the good old American anti-intellectualism of a considerable part of the profession at that time. Hence the new Shingle Style has played a role in renew-ing the traditional humanistic dialogue between the Liberal and the visual arts. It has also been involved with the redis-covery of special American realities and fiercely American tra-ditions after several generations of influence from highly intolerant and increasingly abstract European sources had bred a contempt for those realities and traditions. It is true that "tradition," as distinct from consciously received "influence," might be defined as those influences which are so pervasive in any historical situation that the human beings who are involved in them are not consciously aware of them at all. It is the ultimate model of reality through which the human brain works in every generation. Yet, if that is so, and if the development

of domestic architecture which the Shingle Style of the 1880s climaxed should indeed be regarded as a nineteenth-century American tradition in which contemporary European influences had been subordinated, then that tradition was in fact interrupted by the influx of renewed influence from Europe: Beaux-Arts from the eighties right up to the 1950s, International Style in the 1920s and thereafter. Hence, for a scholar working in the 1940s, the old tradition had to be rediscovered and rehabilitated if it was to become available for use once more. So consciously identified, it became a new "influence" itself, and the forms which first moved me in 1948 to that act of rediscovery were the identical strong forms upon which the new American architects were to focus a decade later. It was McKim, Mead and White's Low House in Bristol, Rhode Island, of 1887, which seized my imagination when I saw it published in Henry-Russell Hitchcock's *Rhode Island Architecture,* of 1939 (Fig. 1). In that sense, Hitchcock, who was then amiable enough to act as one of the advisers for my dissertation, was my direct personal influence, a relationship I have never ceased to acknowledge.

In any event, the Low House, rediscovered, was like the chthonic apparition of a tremendous and hitherto unsuspected local force: a giant out of this earth. It was one enormous gesture, one fundamental act. The continuous diagonal planes of its great gable seemed stronger, clearer and, as I liked to say then, more "archetypal" than any of the more recently modern forms I had seen up to that time. (Though when I first came to write about the Low House in *The Shingle Style* I seemed compelled to write it down and to compare it unfavorably, for example, with the more articulated Cyrus McCormick House. It was my own way of swerving from influence, I suppose.) Still, it can be no accident that such a form appeared just at the moment when American painters were entering their greatest decade, when the space-making gesture

of Franz Kline's "Crosstown," of 1955 (Fig. 3), possible only in America (contrast the finicky inversions of a Soulages), was unconsciously to echo and to outdo the Low House in its crescendo of diagonal lines of force. So when Robert Venturi designed the first major project of the new Shingle Style, his Beach House of 1959 (Fig. 2), he too focused on the Low House but "swerved" from it to thrust an enormous chimney up through the center, like the piers rising up in "Crosstown," a painting which, as a matter of fact, Venturi did not know. Surely Venturi's instinctive objective was to use the Low House but at the same time to destroy it with an act which would make its form his own.

McKim, Mead and White themselves had reacted in much the same way to the work of their honored and envied precursor and rival, Henry Hobson Richardson, in whose office White and (briefly) McKim had both been employed. So the Low House takes the wide gable and the horizontal window bays of Richardson's Watts Sherman House, of 1874 (Fig. 4), the first monument of the Shingle Style, and stretches them further, just as far as they can be made to go. The architects wanted a shape which would outdo that of their precursor in horizontal continuity and breadth. Richardson, in turn, had done exactly the same kind of thing to his own direct precursor, the English architect Richard Norman Shaw, whose work had been influential since the late sixties, and whose "Hopedene," in Surrey, was also published in 1874 (Fig. 5). The horizontal mass of the English house is interrupted by many vertical bays, reflecting the typically English discreteness of room from room within. Richardson discards all the verticals with the exception of the chimneys and uses the long slope of his gable to pull the shape into one unity and to emphasize the greater, and henceforward the typically American, continuity of space which he was beginning to develop inside. Richardson was reflecting in this yet another influence upon him, that from American "colonial"

architecture as it was beginning to be seen in the early seventies: not in its Georgian but in its earlier, more medieval guise. The first colonial house to be published as a photograph in an architectural publication was the Bishop Berkeley House, of 1728, near Newport, Rhode Island, reproduced in the *New York Sketchbook of Architecture*, of 1874 (Fig. 6). That photograph was aimed not at the more or less symmetrical front of the house but at the long sloping gable of the rear. So Richardson's gable was already American, and its shape initiated that dialogue across the centuries which Americans were to take up once again in the middle of our own.

Yet as I worked on the Shingle Style in the fall of 1948 it became apparent to me that it had succeeded another earlier and equally identifiable mode of American domestic architecture in wood. That mode had been involved with an expression of the individual wooden members of the structural frame rather than with the sheathing surface. For obvious reasons, I called it the Stick Style. It had taken shape in America in the 1840s and was disseminated through the mid-century Pattern Books, beginning with those of Andrew Jackson Downing. Many of Downing's ideas had in turn derived from English sources, especially from the publications of the landscape architect and theoretician, John Claudius Loudon (since investigated by my colleague, George Hersey, in his "J. C. Loudon and Architectural Associationism," *Architectural Review*, August, 1968). Downing's Americanization of that Picturesque tradition resulted in houses sheathed in vertical boards and battens which skeletonized the surface (Fig. 7). The lightly framed American porch also appeared in them. By the early 1870s those porches had eaten their way into the bulk of the house, and their framing, like that phantomized across the sheathed surfaces themselves, had burst out into a glorification of all the elements of frame construction: verticals, horizontals, and diagonal bracing (Fig. 8). I called that late phase a "basketry of sticks"

and, in a terminology perhaps overly influenced by that of my ultimate master, Henri Focillon (*La Vie des Formes*, Paris, 1934), defined it as the "baroque" of the Stick Style. It was in any event the denouement of that mode—for the moment at least, since it was to be revived in its essentials in the work of Greene and Greene and Maybeck in California during the 1890s.

In 1874, as we have already seen, Richardson turned the vertical, highly articulated massing of the Stick Style over to the horizontal, opened up its separate interior spaces to each other, and emphasized that new continuity by sheathing over the articulated frame of the exterior with a continuous shingle covering. In this way the essential objective of the Shingle Style was the creation of expanding space, and all the rooms opened widely off a central living hall with a great wall of glass (Figs. 4, 9). That space, though much more horizontally extended and unimpeded than that of its English antecedents, also had a vertical dimension, especially up the great stair with the light pouring down it from above. The interior expansion along those two axes is perfectly expressed on the exterior by the frontal gable of the Watts-Sherman House, whose volume is at once vertically pointed and horizontally stretched.

By the early eighties the new style reached maturity at the hands of Richardson and of many other architects. It was to be the last strikingly inventive phase of domestic architecture in the American northeast until, probably, the 1950s and its own revival. By 1880 shingles covered the entire surface, and the interior space in small houses as in large was one easy flow, monumentalized by the living hall with its entrance, stairs, fireplace, and window wall (Figs. 10, 11). Outside, the influence of early colonial wood construction had simplified all the details and, as in colonial work, the windows were pressed up close to the surface and small-paned (now by purely aesthetic choice), in order to respect the continuity of the

shingle surface rather than to cut a void in it as deeply inset or single-paned windows might have done. Colonial houses were also studied for their massing, especially those which, like the Fairbanks House at Dedham, much published during the period, had been added onto over the centuries (Fig. 12). The resultant intersections of gambreled and gabled masses were much appreciated by the new architects. But the conical pavilion which Richardson inserted into such an intersection in his Stoughton House indicates yet another source of influence: the sixteenth-century chateaux of the Loire, the first unfortified country houses of northern Europe, with their conical roofs, fantastic chimneys, and intersecting loggias and arcades (Figs. 10, 13). Behind these, of course, stood the figure of Leonardo at Amboise, and through him the first of romanticized modern homes, Federigo da Montefeltro's loggia'd and towered palace at Urbino, where Leonardo had worked (Fig. 14).

The historical generalization which immediately occurs to us in this relationship is the impoverishment in size, richness, and complication which the Stoughton House shows when compared with its aristocratic precursors. The country house has now dwindled to a comfortable, suburban middle-class scale and a perishable material. That dwindling of the program and the form is not only economic and political but also symbolic, since the major symbolic content of the Shingle Style houses was not intended to be aristocratic but, at least for a time in the seventies and eighties, overtly democratic, indicating and praising an unpretentious kind of life. Here references to the American colonial were the major symbolic means. The widespread popular revival of interest in colonial architecture in the early seventies, culminating as it did in the Centennial of 1876, focused its attention on old towns, like Nantucket, Marblehead, and others of their kind. Life was regarded as having once been simpler and cleaner in them than it had become in the teeming cities of nineteenth-century America. One could escape

there from a contemporary American civilization which had grown "too large," where Grant "couldn't tell the truth," to a smaller, purer world where Washington "never told a lie." There one could build vacation houses and hope to achieve, or play at achieving, the ancient virtues once more. So the major "semiological" content of the Shingle Style was early colonial in character, and the Shingle Style architects were enormously skillful at weaving it into their horizontally spread-out forms. Take the Jethro Coffin House at Nantucket and the Old Mill in the same luminous town (Figs. 15, 16) and weave them together—house cinematically metamorphosed as frontal, high-gabled, and long salt-boxed all at once; mill merged into lighthouse for a smoking room (Fig. 17)—and out stretches a vacation house by Arthur Little at Swampscott, and many others besides.

Indeed, the Shingle Style developed so quickly and richly in the hands of its architects that it must be regarded as having tapped some fundamental items of American belief: in intellectual pluralism, for example, wherein many divergent attitudes and influences are supposed to merge into an integrated but not "exclusive" whole; in cultural democracy, through which artistic meaning is supposed to be extracted from common forms serving everyday needs at modest scale (for which see especially Cobb, the major verbalizer among the Shingle Style architects: John Calvin Stevens and Albert Winslow Cobb, *Examples of American Domestic Architecture,* New York, 1889); in Emersonian Nature, "the circumstance which dwarfs every other circumstance," into which the man-made shapes, reflecting "the soul of the Workman" streaming through them, are to "nestle." One should add to all this the perhaps paradoxical but equally essential American determination to be protected against the continent's aggressive climate, which is to be achieved by the creation of deeply sheltering, well-heated, well-cooled interior spaces, sheathed in an impenetrable

weather seal. Many American buildings of various periods have represented some of these beliefs and desires; the Shingle Style embodied them all.

Hence colonial influences and symbolism did not at first hamper or restrict the architects of the Shingle Style but released them to achieve the variety of forms they desired. And it must be stressed that beyond their semiological content, those forms were put to fundamental spatial use. That space was what I think we should call "landscape" in character, inside and out. On the exterior the variety of the building's massing was intended to echo and complement the actual hills and head-lands of its usual country or seaside setting (Fig. 18). This was Picturesque design specifically Americanized into one spatial composition of man-made and natural forms. Inside, as we have seen (Figs. 9, 18), the variety was like that of a nineteenth-century landscape painting, where gradations of light —partly in full flood, partly shielded by porches; sometimes golden, sometimes thunderous—defined flickering interior land-scapes at various levels, broader and more extensive than any that Americans had known before and flowing on to the out-side through wide doors and echoing porches. In terms of influence and its anxieties, it might be said that the native architects had been able to face up to their inspiration from the English living hall by Americanizing it through the colonial overlay and by opening up to their own landscape therefrom by means of the peculiarly American porch. In that way they could receive influence without anxiety and find themselves a family tree and a permanent home. Historically, their recep-tivity to early colonial forms and symbols was one especially happy and generically appropriate result of that turn of mind whereby many modern artists have been willing to receive and acknowledge influence only from sources regarded by them as simple and/or exotic, and therefore of no competitive threat. Among modern architects, especially among the most icono-

clastic, such as Gropius, Japanese architecture has largely fulfilled that role. Indeed, its significant influence on modern architecture began with the Shingle Style and again specifically with the Centennial Exposition at Philadelphia, where there was a much-admired and discussed Japanese house with mats, moveable screens, and open spaces articulated by the structural frame with its "kamoi" and "ramma," the horizontal tie or molding and the pierced screen. With adaptations of these elements the most advanced of the American architects, such as McKim, Mead and White, disciplined and interwove their interior spaces and their porches (Figs. 20–23). Their direct Japanese influences, as the Newport Casino, the dining room in "Kingscote," and the halls of the Newcomb and Tilton Houses all show, were not normally from the most classic of samurai sources, but from contemporary Japanese "villas" such as those published by Edward Sylvester Morse in his *Japanese Homes and Their Surroundings*, of 1886. One could say that by the mid-eighties that method of spatial articulation had become a tradition or at least a fashion in general use. At any rate, when Frank Lloyd Wright came to build his own house at Oak Park, of 1889, it was the method he employed (Fig. 24). But, as always from the very beginning of his design, Wright "swerved" from his sources in a way utterly typical of him: by clarifying, simplifying, and abstracting their forms. So the Shingle Style provided Wright with a background which was at once a base and, in the work of its eastern architects, a competitive incentive for his own design. He was lucky to come into history at this moment, and he made the most of it.

Wright's choice among influences seems especially intelligent if we look at what had happened to the Shingle Style as a whole by his time. A contrast between McKim, Mead and White's Bell House of 1882 (Figs. 25, 26) and their H. A. C. Taylor House of 1886–87 illustrates the major development (Figs. 27, 28). The earlier house shows the flowing,

asymmetrical plan, the living hall, the sliding doors, the deep porches, the colonial gables, and the chateau-towers of the high Shingle Style, all free and interwoven, unified by the rich texture of the shingles, while the later house shows the whole design frozen, boxed-in, made more or less symmetrical, sheathed in thin, yellow-painted clapboards, with white Ionic columns and generally rather Adamesque details, and employing a stiff plan explicity derived almost *in toto* from an eighteenth-century source. The reaction from the Shingle Style is almost total. It is from variety toward regularity, from dark colors to light, from inventive recombination to stricter precedent, from inclusiveness to exclusiveness, from a more peculiarly American set of forms to shapes which while American in much of their character (the thin wooden surface in particular) are connected in intention with a kind of generalized, international, classicizing design. The major movement is toward order, and the foundation for the later, more restrictive interpretation of the Colonial Revival and, in larger works, of Beaux-Arts eclectic classicism, are already laid. It is true that shingled houses continued to be built for some years, but there is no doubt that a general dwindling of quality in domestic architecture also occurred; the later careers of architects like Peabody and Stearns, John Calvin Stevens, and indeed of almost all the others, show not only a deadening and stiffening in the forms but also a tendency toward fundamental ineptitude, involving a loss of control over scale, proportion, and detailing in any but the most antiquarian of works. The strings of lyric invention had been cut.

In the largest sense, it was only the formal residue of the Stick and Shingle Styles in porches, bays, screens, textures, and gables that kept the domestic vernacular comparatively humane and lively into the early twentieth century—all slowly to be sloughed away, first by Georgianism, next a little, perhaps, by European "modernism," but then most of all by the

culture of television and automobile, no less than by economics, until the stripped, air-conditioned box of the present emerged. However, for a very few years in the mid-eighties, a new simplified order was achieved through the still inventive and intrinsic vocabulary of the Shingle Style itself. I refer here to the great gable which was developed from the Watts Sherman House of 1874 (Fig. 4), through McKim, Mead and White's Cyrus McCormick House of 1881–82 (Fig. 29), to culminate in their Low House of 1887 (Fig. 1). Here was an integrally geometric and spatial shape which embodied an order more intense than any that the classicizing reaction was able to produce, and it was just at the critical moment of change toward 1886 that another practitioner of the Shingle Style designed his only really distinguished houses. These were the small "Honeymoon" cottages which Bruce Price built for Pierre Lorillard at the new exurban development of Tuxedo Park (Figs. 30, 31, 33). It was, as I pointed out in *The Shingle Style,* from precisely these houses that Wright began. His own house of 1889 is a combination of Price's Kent House with its frontal gable and his Chandler House with its double bays (Fig. 32). Both of Price's houses float a vestigial Palladian window under the gable at the third or attic floor. Wright, already in his characteristic swerve, throws out the attic, jams the whole thing down and combines the Palladian arch, now even more vestigial, with the horizontal windows of the second floor. His instinct was surely exact: to start with the protective gable shape, redolent with the symbolism of primitive shelter, the *ur* house itself, while across its surface he thinly traced one fragile colonial reminder of the whole urban complex of European, classicizing, humanistic tradition which was part of American memory too.

Another element of Price's design, the cross-axial plan (Fig. 33), which had already enjoyed a long if rather submerged history in American planning (cf. my *American Architecture and*

Urbanism, New York, 1969) was much less definitely treated in Wright's scheme. But by 1900 to 1902, Wright had learned how to use it to break wholly free into his own realms of form. In a series of buildings and projects which culminated in the Ward Willitts House (Figs. 34, 35), he definitively broke the grip of his precursors upon him, burst the cross-axis out into space, sloughed off the old shingle covering, abandoned gable and Palladio alike, subordinated the chimney, and permitted the Japanese interweaving of the interior to direct his intersecting masses outward and to float their roofs free from containment at the corners. It was the most released new architecture of the early twentieth century, and I should like, for purposes of brevity, to let the side view of the Ward Willitts House, as published in Berlin by Wasmuth in 1911 (Fig. 36), stand for thirty or more subsequent years of architectural development in Europe—for De Stijl, Gropius, Mies Van der Rohe, and Le Corbusier, for, in fact, what Americans came to call the International Style as a whole. Certainly this simplification is not intended here as anything other than a schematic device. (It is developed further in my *Modern Architecture*, New York, 1961; new edition, New York, 1974.) Yet the new architecture which developed in Europe, diverse though its sources and its intentions were, would never have taken quite the form it did without primary formal influence from Wright and hence, beyond him, from the Shingle Style, out of which his house design was born.

Further, I should like, again for purposes of brevity, to take that European International Style in a sense as the existing norm, at least in eastern architectural schools (though the Beaux-Arts was still alive in the corners), when I wrote my dissertation in 1948–49 and built my cheapest of all possible houses in 1950 (Fig. 37). The first point which may help to justify this deplorably personal reference is that I had asked Frank Lloyd Wright to design a house for me but then couldn't

afford to build it, beautiful and indeed profoundly economical as it really was. Next, when I decided to design my own house, it never occurred to me to try to take Frank Lloyd Wright on (taking on Mr. Flaubert or Mr. Turgenev, Hemingway used to say) by attempting to design in his mature manner. That was a closed system, complex and operable only by him; it had to be left alone. Nor did it occur to me to try to develop something out of Wright's early work or out of the Shingle Style itself. The nice gentleman who sold me the land, upon which he had hoped to found a settlement of "colonial," i.e. more or less "Cape Cod" houses, would have been delighted if I had done so (Fig. 15). But the model of reality in which I was imprisoned at the time made it unthinkable to employ anything other than a flat roof or to put windows in a wall. You had to build a frame with its integral voids. And you really couldn't use shingles: Bill Levitt was, after all, employing hugely over-scaled specimens of them to cover his Cape Cods at Levittown. At the same time I also needed a formal and structural model which was simple enough so that I could handle it in a conceptual sense and get it built in an economic sense. I wanted something typical, not special; and I wanted no part of "design." To those ends I tried to develop a simple pavilion of plank and beam structure, and in so doing produced something that looked a lot like one of the old Stick Style porches out of Downing's books (Fig. 38). Meanwhile, architects in California, working in what Lewis Mumford was then calling the Bay Region Style, were also exploiting some of the possibilities of plank and beam, and I was not unaware of their work, though not especially focused on it. (My structural diagonal sheathing was suggested by that on Marcel Breuer's house at New Canaan.) In a sense, the Stick Style itself had never entirely died out in California since the vertically boarded and battened shacks of Gold Rush days, and toward 1950 California architects were consciously reviving it (Fig. 39). Its late, highly

articulated phase had indeed been powerfully revived once be-
fore by Greene and Greene and Maybeck toward the turn of the
nineteenth century. Its skeleton structure had markedly modi-
fied the influences those architects absorbed from the Shingle
Style and played a part in transforming it into what Californians
like to call their own "Brown Shingle Style" of the early twen-
tieth century. Still, the most crucial influence on my house of
1950 came from what might be called the Very Late Interna-
tional Style in its own classicizing or academic phase. This was
represented for me by Philip Johnson's house in New Canaan, of
1949 (Fig. 40). Its simple, single space, clearly defined as one
flat-roofed volume, no less than its sliding curtains and masonry
service core, played a part in producing the central core and the
surrounding open pavilion of my own, large-family, poor-man's
version. The same *partie* (and the old Beaux-Arts term seems
appropriate) shaped Kahn's Art Gallery at Yale of 1953. Here,
too, the strictly volumetric geometry and the box shape were
ultimately derived from Mies Van der Rohe and also recalled,
for example, the H. A. C. Taylor House (Fig. 27) rather than
the Shingle Style.

Kahn was the major American influence upon young archi-
tects during the fifties and early sixties, especially upon those
students and collaborators of his who were eventually to shape
the new Shingle Style. But his own formal predilections, as
apparent in his Art Gallery and elaborated in his spectacular
production later, were fundamentally counter to those of the
Shingle Style, stressing as they did symmetry, cubical contain-
ment, and neo-Beaux-Arts structural and spatial discreteness
and order. Yet this may be one reason why Venturi, working
with Kahn when he opened the new movement in 1959, fixed
on the geometrically simple and more or less symmetrical
Low House as his model (Figs. 1, 2). It was the moment of
bringing order that he sought out, as I too had done in The
Shingle Style a decade before. The strong, awkward chimney

of Venturi's project also recalls Kahn's marvelously ugly and burgeoning forms of the fifties, when he was still reaching powerfully and bravely out toward his own new system and shapes (Fig. 42). Hence Kahn probably both retarded the coming of the new Shingle Style and, by breaking the grip of the International Style, eventually made it possible. He liberated his students from a worn-out model, and Venturi's project of 1959 is their own proper beginning. Yet that project looks forward so fully to the most recent developments of the movement in the early seventies and indeed already charts the main line of its development from the late fifties up to now, that it seems preferable to leave it and its line until later and to work our way into the movement as it can be seen in the development of the design of other architects.

That of Charles Moore immediately comes to mind for a number of reasons. First, Moore was also a student of Kahn's, in his case as a graduate student at Princeton during the fifties. Next, Moore has volunteered the information (as few do) that he had read my publications of the Stick and Shingle Style by 1955 and so became interested in their possibilities at an early date. At the same time, Moore is fundamentally a Californian, at least by choice and in outlook, so that the Stick Style component is always especially strong in him, and he has rarely entered so fully into the Shingle Style itself as some other architects have done. Moreover, the development of his work significantly reflects many subsidiary American and European influences which are related to the larger contemporary movement toward the new Shingle Style. So Moore's career makes a good introduction to the historical setting and the contemporary problem as a whole. His own house of 1961 is one of the units of Kahn's Bath House at Trenton, of 1955, somewhat reordered inside and with a good barnlike quality in its sliding doors and conspicuously plastic shingled roof (Fig. 43). This feature reflects other simple,

more or less shacklike houses well in the California tradition
that Moore had already built by that time. (For Moore's early
work see Charles W. Moore, "You Have to Pay For The Public
Life," *Perspecta, the Yale Architectural Journal, 9/10, 1965.)*
By 1965–66 he was well into his Sea Ranch condominium,
which probably still remains his masterpiece in domestic design
in wood (Figs. 44, 48, 49). It is beautifully sited and composed
in relation to the shapes of the headlands and under the sea
wind, but the tautness and sharpness of its forms distinguishes
them from those of the Shingle Style. Nor are the walls
shingled, and Moore has pointed out that many of his houses
which he would normally have shingled are instead sheathed
in some other way because shingles are no longer an inexpen-
sive cladding material. Here a further economic dwindling
from the state of affairs in the eighties makes itself felt.

A whole raft of anti-International Style influences, both
European and American, can also be deduced at Sea Ranch: the
Alvar Aalto of Saynatsalo (Fig. 45), representing a real break
with the International Style in favor of more local, vernacular
design, of which American architects had generally become
aware by the mid-fifties; similar non-International Style archi-
tects of the twenties, like Bijvoet and Duiker (Fig. 46), re-
published in an article by the English architect Colin St. John
Wilson in *Perspecta, the Yale Architectural Journal, 7, 1961*
(all surely reflecting some influence from projects of the fifties
by Peter and Alison Smithson and Stirling and Gowan which
restudied the viability of vernacular shapes and details);
Edward Larrabee Barnes, with whom Gio Pasanella and
Jaquelin Robertson worked at this period, and his shingled,
steeply shed-roofed Haystack Mountain School of Crafts, of
1962 (Fig. 47); finally, Greene and Greene and Maybeck, and
the pervasively Californian Stick-Style tradition itself. So the
massing of Sea Ranch rises in vertical shafts, and the interior
spaces, too, are high and elaborately articulated by exposed

framing members (Figs. 44, 48, 49); they do not swell and are not volumetrically rounded in the Shingle Style manner.

That quality of space as corridor or flue, or as deep pool rather than balloon or bubble tends to remain characteristic of much of Moore's design to the present time. The Stern House, of 1969, is an excellent example (Figs. 50, 51). The double-height spaces and the strong diagonals may recall those of the Shingle Style, but the effect, like that of the boarded exterior, remains tighter, sharper, and more tense. Those qualities often remain constant in Moore's work even when he moves toward a more volumetric, Shingle Style type of plan. His Klotz House of 1960 might be compared in plan to Bruce Price's Chandler House, where a diagonal axis is thrust through a square, and polygonal spaces swell out to articulate the corners (Figs. 52, 53). Yet Moore more actively "deforms" the basic rectangular shape than Price had done. We recall Kahn's discussion of Form and Design, where the first form suggested by the mind for a new project is tested by its deformation according to the empirical demands of the program's particular requirements. If it deforms too far a new form must be chosen. It is the very process of deformation that Moore takes delight in building, and it makes his production physically and intellectually unique in architecture. But again, a plan like William Ralph Emerson's for the General Charles Loring House, of about 1884, shows diagonals similar to those of Moore and a related bayed treatment of the projecting edges of the volumes (Fig. 54). The published sketches of it by E. Eldon Deane, the demon renderer of the 1880s, show another Shingle Style characteristic newly exploited by Moore: the tendency to design in picturesque pieces, to put the composition of the house as a whole together out of bits (Fig. 55). The differences, though, are again important, because the typically Shingle Style house, like the G. N. Black House by Peabody and Stearns, for example (Fig. 56), eventually brought

all the bits together into one swelling volumetric shape like H. H. Richardson full of oysters. Moore does not do so, and clearly does not want to do so. His shapes, as in the Klotz House (Fig. 55), remain separate, nervously articulated, sharp-edged in their thin boarding, and as varied as possible, though dragged marvelously up the hill as by the stretched roof plane of the high porch at the summit. "Deformation" is taking place before our eyes, like some agonized biological metamorphosis. It is to be found movingly developed in Moore's Gagarin house as well.

The "dwindling" of the domestic program which we noted earlier now seems to take on renewed historical meaning. Once again it is not only economic but psychological and symbolic as well. Things are now what they were in the 1880s. This is a tenser and more straitened age, and Moore's forms entirely express that difference. If this is so, how can he go beyond the precursor, how mark out his own terrain? Moore's fundamental answer seems again to be a significantly contemporary one. He will free himself not only by twisting out and away, and through maximum variety of sensation, but also through irony, by consciously undercutting the pretensions of the program and kidding it, as if to say: Sure, the overall possibilities are less, but the intellect is quicker and sharper; we can have impoverishment with wit. Moore can sometimes pull all this off with considerable eloquence. His project for a resort hotel on St. Simon's Island in Georgia is a good example of that (Fig. 57). It starts with the great, many-dormered roofs of the expansive resort hotels of the eighties, like the Thorndike and Bayview at Jamestown, Rhode Island (Fig. 58). But the program has dwindled, so let's cut the rest of the building out from under the roof and drop it to the ground. In this way, too, the shape could be made to hug the dune line and to preserve the environment—which, Moore has said, he attempted to do at the behest of a developer who needed a

permit for building but, that attained, then opted for a series of high-rise slabs. So seen, Moore's project is pure if amputated Shingle Style, but the great roof is ripped open inside and a whole Latin Quarter of jazzy, stage-flat, brightly painted facades is revealed (Fig. 59a). The contrast is entirely appropriate but also consciously witty and ironic; it may be said to sum up many of Moore's fundamental intentions.

A general pattern of relationship between new and old Shingle Style may now also be perceived: single-family suburban or resort houses have dwindled in formalistic potential. They cost more to build. Partly in consequence of that, but clearly expressive of deeper psychic changes, the forms become tauter, more nervous, less generous and full than the older ones. A student of Moore's such as Tim Prentice will recognize this fact by tightening his shapes into a simplified rural vernacular. But now the youngest ones, such as Turner Brooks up in Starksboro, Vermont, who had participated in Moore's and Tom Carey's rural assistance project in Kentucky, of the late sixties, are beginning to extract a new richness and solidity of expression from that vernacular (Figs. 59b,c,d,e,f). They have opened their eyes to Stick and Shingle Style alike, but most of all to the dignity of the process of building itself. A kind of stern grandeur is resulting, developing rapidly in scale over the past couple of years, and it—along with the work of some other young architects working in Vermont—will soon require a special study of its own. Up to now, however, the forms of the new movement have tended to become more ironically active, like nervous creatures. Hardy, Holzman and Pfeiffer's Hadley House at Martha's Vineyard is a good illustration of all these qualities when compared with a project for Bar Harbor by William Ralph Emerson, of 1885 (Figs. 60, 61). The rounded, swelling lighthouse and the sweeping porches of the one have been literally chopped into the single open terrace of the other; the gables achieve a cutting edge. The early house

gestures expansively; the modern one reacts nervously—so much so that its flag lifted at the edge of a beautiful and desolate landscape takes on some special poignancy. But again, if we compare a typical Shingle Style house on the cliff at Siasconsett on Nantucket with one of the last unrehabilitated fisherman's cottages in the town of Siasconsett itself (Figs. 62, 63), we see that the architects of the Shingle Style produced forms which were larger, fuller, more physically optimistic than those of the old colonial houses which had influenced them. In that particular relationship no impoverishment had occurred. America was bigger in every sense. (Giving the lie, one must add, to the repeated statement in the Guidebook of 1967, published by the Nantucket Historic Districts Commission, that "Nantucket's architectural development really ended in 1846"; more or less true for the center of the old town itself, but a whopping fib in regard to the rest of the island, which contains a number of distinguished Shingle Style houses and over which, since 1970, said Commission claims total stylistic jurisdiction.) Now the process reverses itself, and another view of the Hadley House shows forms which, like those of Moore's Klotz House (Fig. 55), are less volumetric, more involuted, and much more nervously reactive than those of their precursors (Fig. 64). America *is* more rackety, less optimistic now.

Bloom, in his *Anxiety of Influence* to which I referred earlier, sees a continuous chain of influence in English poetry from Milton on, and he asks if, especially since Romanticism, this has not entailed an impoverishment of the art, because the precursors are so great that the followers must tend to do most of their "swerving" and so on within, or at least always in relation to, the forms of the older masters. Can something like that be the case here—indeed, in the larger sense, from Chambord to the present (Figs. 13, 64)? The question is in fact not so simple. For example, one obvious fact about many of the new Shingle Style houses is that they have inevitably

been influenced by the International Style as well: that itself involved a thin, taut set of forms, though they might also be taken as expressing various kinds of dwindling. Whatever the case, many of the new houses must be analyzed as recombinations of the influences their designers have received from Europe as well as America. The work of Romaldo Giurgola, born in Italy and now residing in America, offers appropriate examples. On the one hand, his Dayton House of 1970 employs the thin white surfaces, flat roofs, and horizontal window bands of such International Style houses of the 1930s as that designed by Richard Neutra for John Nicholas Brown (Figs. 65, 66). On the other hand, if we now wheel up a perspective of "The Craigs," by Bruce Price, of 1879–80 (Fig. 67), we can see that Giurgola's overall composition of masses is much more like Price's than Neutra's. Exactly the same can be seen in plan: diagonals push through, rounded bays belly out, sharp voids cut the corners (Fig. 68). These combinations carry on to be gently and beautifully resolved by the younger generation of architects, as in the Snell House by Frank Israel, who was one of Giurgola's pupils (Fig. 69). And they are profoundly spatial as well. The interior of Giurgola's Dayton House is that of McKim, Mead and White's Goelet House (Figs. 19, 70)—with its monumental fireplace, its varieties of light, and its high galleries—which has been lightened, tautened, and dramatized by the hall of Le Corbusier's Maison La Roche, of 1923 (Fig. 71). Yet we cannot let these obvious contemporary syntheses pass by without at least the indication of a possible historical connection between Le Corbusier and the Shingle Style itself. The hall of the Maison La Roche, for example, recalls the one in Arthur Little's Shingleside, of 1881, which was published in the English *Building News* of 1882 (Fig. 72), the first Shingle Style house to be so singled out abroad. We know further that Adolf Loos, whose concepts of space clearly had an effect on Le Corbusier, traveled in America and appreciated the shingled houses, whose influence can in

fact be observed in plan and massing from Holland to Vienna in the early years of this century. (About this much more work needs to be done.) Little's two-story wall of glass for his hall even looks forward to Le Corbusier's Citrohan type in its height (Fig. 76), while its curve seems a possible precursor to other European glazing experiments of the early years of the twentieth century.

To go further: the influence of Le Corbusier has to be pervasive at the present time, so heroically "influential" an architect he was. But the influence of the Shingle Style is becoming no less so. It was a powerful architecture, too, and one especially adapted to American building conditions. The work of an architect like Charles Gwathmey, who has been protestingly bundled into the neo-Le Corbusian camp in a recent publication (*Five Architects*, New York, 1972; "Don't put me in with those white architects," Gwathmey says, but he doesn't want to be grouped with Moore or Venturi either) is an example of how the contrasting influences may in fact tend to come together. Gwathmey's house for his father slides Shingle Style diagonals into the Maison Citrohan and intersects them with cylinders which, in plan, recall those of McKim, Mead and White (Fig. 73–76). Even the more recent abstractions of a devotedly pictorial practitioner like John Hejduk may seem derived in part from somewhat similar conjunctions. Then Gwathmey sends the subsidiary studios humping out across the landscape (Fig. 77) in an especially dynamic version of the angular rhythm and the rather ironically active creature-quality we have noted before, as in the Hadley House (Fig. 60).

Much the same set of combinations seems to have formed the little towers of Gio Pasanella, which wrap themselves up in a cloak of shingles (Figs. 78, 79a). They are at once gentler and more proudly figural than Gwathmey's work normally is, but they wed Le Corbusier to the Shingle Style in rather similar ways. The beach houses at Long Beach Island by Murphy–Levy–Wurman, on the other hand, apply shingles to broader,

squatter cylinders, reminiscent of Kahn's famous project for parking garages to ring the center of Philadelphia, and of his abstract geometry at Dacca and Ahmedabad. These group as a composition by the sea, disquieting in scale and jack-o'-lantern masked (Fig. 79b).

The work of Jaquelin Robertson represents another kind of synthesis between Europe and America, no less than between large urban conceptions and domestic forms. Like Gwathmey, Robertson was a student at Yale, and he studied and worked in England as well. Preoccupied with planning and for many years a dedicated public servant in New York, Robertson has so far built only one house in America, the Seltzer House at Sagaponack on Long Island (Figs. 80–84). Here Bijvoet and Duiker (Fig. 46), and through them Robertson's work with Colin Wilson at Cambridge, are instantly recalled, but the house is exactly right in terms of its particular function and place. It is set at the only point on its lot from which a view of the sea can be obtained, but the major sweep of Shingle Style porch aims for the largest view across the property which is consistent with privacy. The round porch pillars are bolder, less "witty," and less tautly nervous than most modern work. The interior spaces—no rooms really, only functional areas borrowing space from each other—push out toward the porch and up the stairs, so creating a true living hall at the new dwindled scale by making the necessary space for the stair itself do it all (Fig. 83). From the upper levels the single view of the sea is cut through the tautly glazed walls (Fig. 84). Here wood and glass both stay on the surface not by similarity of pattern but by seeming equally stretched. In all this the Seltzer House embodies a probity, a solemnity even, which seems at once especially awkward, promising, and right, much as Kahn's early work seemed in the fifties. It all feels more like "tradition" than like "influence," if one can be permitted to put the feeling that way.

Yet the line of most intense influence from past to present

remains to be investigated, that along which the contest between the present generation and the precursors has been most keen and the larger artistic implications of the whole movement most clearly apparent. I once more refer here, of course, to Robert Venturi and his death grapple with McKim, Mead and White. But Venturi was not the first of contemporary architects to fix on the Low House. That honor belongs to George Nelson for his Spaeth House of 1957 (Figs. 85, 86). The contrast between what Nelson does with the Low House and Venturi's reaction to it two years later is enormously instructive. Where Venturi was to blast a chimney up through the center of the gable (Fig. 2)—so, as it were, taking it all as far away from McKim, Mead and White as he could: the implacable reaction of the strong poet—Nelson simply lets McKim, Mead and White roll over him (Figs. 85, 86). He obviously feels no anxiety or resentment and is not tempted to compete. His house, well but less dramatically sited, is weaker than theirs: thinned at the edges, softened at the gables, happily discovering that shingles can make rounded forms. By contrast, Venturi is ferocious. His project is much smaller—again the dwindled program—and it is hoisted as a thin box on its short piers. But his chimney, the first high chimney other than antiquarian ones in American domestic architecture since Shingle Style days, changes it all and intensifies the symbolism: not only gabled shelter now, but shelter and fire (Figs. 1, 87, 88). One recalls Wright's middle-western fireplaces "burning in the heart of the house." This chimney rises higher, as a signpost of Home facing the Atlantic. Again one recalls Kline's enormously American forms (Fig. 3). They also show us that Venturi's Beach House belongs to the heroic American Abstract Expressionism of the fifties. At the same time, the intersecting slanted roof planes and the powerfully abstract chimney all suggest an Americanization by Venturi of a direct English source of his own, specifically of Middlefield, in Cambridgeshire, by Sir Edwin Lutyens (Fig. 89), of whose

work Venturi has always been extremely fond. The Low House
is the direct heroic precursor for Venturi, certainly, but the
buildings of Lutyens—perhaps especially the smaller houses
which had themselves dwindled from the larger Victorian pro-
grams but some of whose details, like those of Colonial America
before them, remained at the old enormous scale—were full
of suggestions too. (Cf. Lawrence Weaver, *Houses and Gardens
by E. L. Lutyens,* London, 1914.) These are curious inter-
relationships, where Lutyens had most probably never heard
of an American house like Stratford (Fig. 90)—but was dealing
with the same problem: the simplification of older and larger
forms—while Venturi knew him and it alike and, as an Ameri-
can, understood and needed what Lutyens was doing more than
Lutyens's English descendants seem to have done.

But if one were a student of Venturi's—subject to his in-
fluence by instinct and conviction but forced like all human
beings to make it on one's own—what could one do with that
chimney? Richard Weinstein answered that question defini-
tively: he pulled it out by the roots (Fig. 91). Moore's Jenkins
House project of 1961 had already taken much the same
amputatory route, though it had characteristically lopped off
half the gable as well (Fig. 92). (But it was to appear whole once
more, in brick and complete with chimney, as the facade of the
little dining hall stuck in behind Kahn's noble library at Exeter,
finished in 1973. It thus slyly reassumed the symbol of
medieval kitchen which its shape suggests.) Still, the chimney
and the gable carried Venturi's project beyond Abstract Ex-
pressionism to what might be called the "Signpost Art," the
signaling art, of the following decades. They semaphore (hence
"semiological") what the house means, here roof and fire and
taking possession of a place (Figs. 2, 87). They are directly
and simply symbolic, though perhaps "significatory" would be
a less loaded if also less graceful word. It is in that direction
of by no means mysterious symbolic expression, rather than
toward a preoccupation with spatial and structural complication,

that Venturi's work thereafter generally runs. That interest links him with a number of English critics (as in Charles Jencks and George Baird, eds., *Meaning in Architecture,* London, 1969) who have otherwise tended to be rather hostile to his and related American work and intentions. At the same time, Venturi's simplification of space represents another realistic appraisal of the impoverishment of the program; fundamentally, there is little money for large or complicated domestic interiors any more, and there will be less in the future (Fig. 88). The plan of the Beach House project, for example, shows none of Moore's spatial elaborations and games; it is straightforwardly inflected along taut diagonals by the simple functions it serves, and it relies on the lift of the fireplace mass to give it vertical breadth and emotional meaning. But the experimental lateral deformations of its exterior envelope, as of forces pulling away from the static mass in the center, would seem to have affected Kahn's plan for his Goldenberg project, which was to have considerable effect upon Giurgola, Moore, and others.

This is not to say that Venturi remained indifferent to further spatial experiment and proliferation. He did not, and, though sticking to his symbolic focus, he turned to the Shingle Style for spatial suggestions. His first Frug House is still Low-House derived, simplified down to its two major elements of chimney mass and living space to the point where the living room is almost purely a fireplace inglenook (Fig. 93). Then, in the second Frug project, Venturi begins to set up close-packed planes of wall one behind the other, the house layering down into its inglenook-fireplace spatial core (Fig. 94). Here one cannot help but recall not only Kahn's "wrapping" of arched "ruins" around buildings, of c. 1960, but also the pervasive inglenook fantasies of the Shingle Style, and specifically such houses near Venturi's home in Chestnut Hill as the Charles A. Potter House by Wilson Eyre, of c. 1885 (Fig. 95). Its porch seat is recessed under a wide arch; the gables overlap

and slide in plane, and the porch cuts under, so that the house reveals itself in spatial layers. This is exactly what Venturi tries to accomplish in the Frug Project, showing his characteristic swerve from the precursor toward the compaction of the whole. Influence's anxiety makes itself felt when Charles Moore is moved to adapt Venturi's project for his Goodman House of 1970, though the stretched pull of his own Faculty Club for Santa Barbara, lighted through arched layers which may derive from Kahn's project for the Mikveh Israel Synagogue, can be felt in it as well. Where Venturi forcefully unifies the whole by means of the single symbolic and spatial gesture, Moore's reaction is to multiply, complicate, and confuse it. His project writhes off the chimney as if trying to make itself five other things (Fig. 96). Moore has said that he is unsympathetic to the "symbolic" interpretation of Venturi's work. Clearly, its unconcealed focus, its semiological directness as a billboard, is not consonant with the jester's mask that Moore so likes to don. At the same time, unlike Venturi in design and myself to some extent in writing, Moore has seriously directed his major attention toward the Shingle Style's suggestions for heterogeneous variety rather than for overall order. His approach is thus entirely opposite to that of Venturi's; it shows how several different kinds of method may derive from Shingle Style influence and be supported by it. Still further back and relevant for both architects, as for Wright (Fig. 34), are the central chimney masses of old colonial New England houses with their skeleton frames clinging to them and their small hollow volumes of living space warmed and stabilized thereby. (See Melville's story, "I and My Chimney," which I cited in relation to Wright: *Frank Lloyd Wright*, New York, 1960; it is even more apt for these architects.)

By 1960, one year after taking on McKim, Mead and White, Venturi was apparently ready to have it out with Wright himself, the Champ, as Hemingway would have called him.

Another reference to Bloom would not be amiss in this connection. He notes that the "strong poet" seems to go for the youthful rather than the mature work of his chosen precursor, because there it is still yeasty with the older artist's own gropings for form and is therefore at once more accessible to development and susceptible to swerves. I would add that in the case of an architect like Wright the early work may also be in every sense more fundamental, itself beginning near some true source of all architectural meaning and form. Indeed, Wright's own house, as we have seen, was the culmination of what I called in *The Shingle Style* the "archetypal" group of gabled buildings of the eighties. Bloom also notes that a successor may so develop out of the early work of the precursor as to make that work look like a less articulate, less considered, perhaps even less successful version of his own. In a way, Wright had already done that to Price. His own house makes the Kent House, for instance, look overassertive, untidy, and somewhat *louche* (Figs. 30, 32). Wright is very proper, neatly composed. Venturi then takes that form, with the drifting Palladian memory which Wright was so soon to jettison, and plays every kind of change upon it. His eloquent project for Millard Meiss, of 1962, generously spreads gable and window and makes Wright look a bit parsimonious and prim (Fig. 97). The history of art is strewn with the frustrations of beautiful buildings unbuilt. The Meiss project is surely one of them. It, too, is in two major planes slanting broadly, like the cross-axial mass behind, say, the Kent House's frontal gable. Its treatment of the window may also have been affected by the Roman "ruins wrapped around buildings" of Kahn's project for the American consulate in Luanda, of 1959–62. Or in the D'Agostino project, Venturi will wed the arched window to the stepped Dutch gables of a glorified 1920s garage and make the Wrightian original look careful and a little dowdy (Fig. 98). But when Venturi came to

his family's house, of 1960–63, there was something deadly serious involved in the relationship. First of all, the "dwindling" is being squarely faced (Fig. 99). The new architect is standing up in the poverty of his time to confront the comparatively affluent master, and he is fighting to put that very limitation to use if he can. So he dumps the building on the ground: no expensive terrace. No shingles, either: too expensive too, as we noted before. If so, then let the house be made, or appear to be made, of cardboard, like the rickety cardboard models beloved by Kahn. Indeed, let the house look like a model, the dream of a house, the absurdity of Le Corbusier's "rêve a deux millions," ironically acknowledged. Can't afford to change plane for the gable either; then let that overhang dwindle to a horizontal molding, and let the windows hang off it, stand on it, or run along it with the varying specific gravities their functions provide. Most of all, let there be the Palladian arch, but tack it on as if it were a two-by-two afterthought, wholly vestigial now. And break the gable, open it vertically with phantom stairs just visible at a plane behind it, leading the eye upward—whence? Above the void, a chimney block seems to rise. Here we should see Stratford again (Fig. 90) in this subtle compaction and metamorphosis of wings, chunky chimneys, stringcourse, central void, and stair. Ultimately, it is lordly Blenheim, with its grouped chimneys and split pediment, that stands at the beginning of this precursorial line. The dwindling is almost total. But Venturi needs only his lifting gable plane that makes his little house big—much bigger at the end of its axial driveway than (and one hates to say it) the tight little chalice of Kahn's Esherick House just up the road.

The plan (Fig. 100) of Venturi's house is also important and new in its time: not a geometric explosion, like Wright's, or a geometric reimposition of containment, like Kahn's at that period (Fig. 101), but a Shingle Style plan out of one of Eyre's houses nearby (Fig. 102). It, too, is "inflected" and flexibly

"accommodating," but Venturi's is smaller, less expansive, apparently impoverished, confined in the cardboard box of modern reality. Once again, the main space at first seems to be largely a throwaway, except for the monumental Shingle Style stairs, wide below, smaller above. But these are appropriately sanctioned by the deeply curved rise of the living room's ceiling, through which the Palladian motif, apparently wholly dwindled to mere line in the facade, is now shown to be working spatially after all, opening volumetrically up through the house (Figs. 103, 104). This is the great swerve from Wright, putting memory to fresh uses along new paths Wright had not trod. Wright had chosen to spread out on the horizontal and so discarded the gable, but Venturi now exploits its vertical dimension. Now the Palladian window indeed rises up through it to an integral upper space with an arched window which, unlike Price's or Wright's, is truly functioning in a spatial climax but which reveals itself only at the back of the house on the second floor (Figs. 105, 106).

Almost immediately, Venturi's most devoted follower and first serious, sympathetic critic, Robert Stern, tried to begin his own design, in his Wiseman House, with that facade and its arched window, and he attempted to do to it what Venturi had done to the Low House: to explode it (Fig. 107). He tried to pull it upward in space and to stretch it out as an archway greeting the motorist to Montauk as he approached up grade from the west. The notch in Venturi's facade below the window, as well as the recessed plane behind the split gable on the entrance side, then suggested to Stern the deep trough cut back into the facade of his Wiseman house, and Venturi in turn has said that this suggestion supplemented those of the Shingle Style in the overlappings of his Frug House project. Yet if Stern swerves from Venturi he also, in this first attempt, clearly buckled a little too, and the "inflections" of Venturi ran riot in his plan (Fig. 108). Again, a central problem of identity under

influence is apparent. That problem is certainly aggravated for Stern by the fact that he is a critic and historian of modern architecture as well as an architect. Like all such marked men, Stern often cannot help appearing rather heavy-handed in artistic execution, since he is openly responding to influences of which he has to be all too consciously aware. He cannot make believe they are not there, as many less burdened artists are perfectly able to do. Venturi himself, for example, is characteristically grudging in terms of acknowledging precise influence, despite the generalized Pop-Art, Art-Historical, and Team-Design show he puts on. Wright and Gropius, unlike as they were, resembled one another in this. They never really acknowledged anything, ever, except some exotic bit, as we noted before. ("Son," Wright once said to me in response to a perhaps rather naive question of mine about Bruce Price, "architecture began when I began building those houses out there on the Prairie." Authentic old American tall talk and corn. How we miss it.)

Stern's special problem remained: how to escape from the precursor? For him that answer lay in digging back into the Shingle Style for himself. His Long Island House of 1972 is adapted from McKim, Mead and White's Morgan House at Newport of 1888–91 (Figs. 109, 110). Stern again sets the two wings side by side and then pulls space in an eccentric diagonal asymmetrically through the mass which, like McKim, Mead and White's, is then distorted by it into a projecting bay on the sea side. Inside, too, the spatial volume reflects that diagonal in elevation as well as in plan, while Venturi's enclosing layers of space in the Frug project become ventilating air shafts which set up an integral flow of cooling air through the house (Figs. 109, 111).

Finally, in his Saft House of 1973, Stern is ready to take on Arthur Little's "Shingleside" itself (Figs. 72, 112), as the Europeans may well have done before him: not only with two-

storied volumes of interior space but also with the layered exterior and the curving glass bay, outside which the columns are now made to appear as if they were hanging vestigially from above like purely spatial rather than structural elements. The struggle is obvious, and of considerable interest, if unresolved; and a positive reference to Moore's work rather than Venturi's may be felt in this instinct toward the Shingle Style's diversity rather than its unity. Still, Stern's gentlest and most generous design is the expansive dining porch he added to a Shingle Style house he purchased at East Hampton (Fig. 113). It replaced a rather unsympathetic addition which had been attached to the house earlier by an International Style architect out of that iconoclastic era which ignored the Shingle Style. That little addition had cataclysmically blasted the old house, much as the large, International Style planning concepts were bombing out old towns under redevelopment in the 1960s. Yet Stern's design, too, represents a thinning out in detail from that of the old Shingle Style, richly plastic and modulated in plane and material as its elements had been (Fig. 114).

So the larger impoverishment, however costly the project, is a real one today. It is built into modern life. How to put it to positive use? Here once again we must turn to the work of Venturi, especially to his Trubek and Wislocki Houses, on Nantucket, of 1971–72. On that incomparable island, where so much of the Shingle Style had originally been inspired, and where its essential colonial symbolic images may still be seen, we can most readily apprehend the meaning of the whole double development, that of the eighties and that of today. The two new houses stand side by side on a bluff above the bay at Pocomo, with every variety of old and new shingled house, from 1973 to 1686, to be found not far away (Fig. 115). But these two stand very much alone, and their tall vertical stance gives each of them a special quality as a person; we can empathize with them as the embodiment of sentient beings like

ourselves. Indeed, Venturi has acknowledged the influence of the Greek temples at Selinus in their placement (see my *The Earth, the Temple and the Gods: Greek Sacred Architecture,* New Haven, 1962), since they turn like two bodies slightly toward each other as if in conversation. Here semiology approaches its essential, which is the action of people talking to each other: not now gods, like the being embodied, for example, in the high, taut Temple of Athena at Paestum (Fig. 116), but common creatures dwindled to modest human scale. "Learning from Fort Dix," the owner remarks of the landward facade of the smaller house (referring to Robert Venturi, Denise Scott-Brown, and Steven Izenour, *Learning from Las Vegas,* Cambridge, Mass., 1972, a gaudy but enormously intelligent companion to Venturi's sober *Complexity and Contradiction in Architecture,* New York, 1966). The larger house completes that spatial movement upward through the Palladian gable which Venturi had initiated in 1960. It is a house proud of its ancestry. It has reconquered Tradition, but its monumental chamfered side, housing the mounting stairs, is also a natural target for approach and parking (Fig. 117). The windows of each house are in tension with those of the other, a family in response and withdrawal. The conversation is difficult; the gables are lance points in an electric sky; the smaller more slender house withdraws from the other broader one. How lonely each seems, as Americans have somehow always felt themselves to be. How stiff their backs. Up through the smaller house the stair gives out to the front bedroom, whose grand, vernacular, double-hung window opens only on the blazing blue of sky and sea: a Hopper, the Atlantic light burning (Fig. 118). Now Wright's old house in Oak Park really does look like what it was: unquestioningly suburban, well-protected on a leafy inland street in a peaceful nineteenth-century suburban town (Fig. 32). For these new houses on archaic Nantucket there is no planting, and the height of the block foundation is as it has

to be, unadorned. How hard is our American present, it seems to say; how threatened, beneath the superficial affluence, with instant poverty on a national scale. How threadbare plain the "real," the beloved, America has always been in fact, but how, like these houses stretching upward, it yearns. Now the poem by Wallace Stevens which I quoted at the beginning of my book on Wright, of 1960, should be transferred to these houses. It is even more appropriate with them, where its Emersonian image is stripped and clearer:

> How does one stand
> To behold the sublime
> To confront the mockers
> The mickey mockers
> And plated pairs?
>
> When General Jackson
> Posed for his statue
> He knew how one feels.
> Shall a man go barefoot
> Blinking and blank?
>
> But how does one feel?
> One grows used to the weather,
> The landscape and that,
> And the sublime comes down
> To the spirit itself,
>
> The spirit and space,
> The empty spirit
> In vacant space.
> What wine does one drink?
> What bread does one eat?

With the Trubek and Wislocki Houses we are in the presence of what modern architects have always said they most wanted: a true vernacular architecture—common, buildable, traditional in the deepest sense, and of piercing symbolic power. It is the bread and the wine united to the sublime as sustenance no less than symbol. But architects have mostly

not really wanted a vernacular at all, lest it cut them out. They are, like all modern artists, necessarily restless men. The architects of the new Shingle Style are not less so, despite their disenchantment with "progress" and their sympathy for the vernacular forms. Therefore—if I may be allowed a minor prophecy of very short range—many of them seem to be moving (though perhaps not their younger students, such as Brooks and others) much as the architects of the first Shingle Style moved: toward a somewhat more cubical, perhaps a more "classicizing" kind of design. Not, it must be said, toward either McKim, Mead and White's literal classicism of precedent, or Wright's strict order of integrated type and progressive development, but toward something much more like the work of Lutyens, which eventually tended toward a kind of classicism too, but which remained varied and eclectic, and in a sense refused to "progress" or to tighten up into a closed system. Here, it is the Lutyens of houses like Heathcote who comes to mind: more symmetrical, heavier in detail, but still explosive in scale and full of every kind of spatial wonder within (Figs. 119, 120). Venturi and Stern are especially drawn by Lutyens (Figs. 121–123). Moore, apparently, is less led toward contained forms, except in housing, but he too seems to be trying for bigger scale—towards which younger architects such as Brooks seem to be naturally heading as they encourage and learn from the work of rural carpenters (Fig. 59e). Yet the modern work still lacks the old classical vocabulary of detail for expressive changes of scale—for bigness in the little, which Lutyens and, for example, Jefferson at Monticello, could both achieve. Leaving aside Venturi's (and Stratford's—Fig. 90) chimneys, such expansion of scale must now usually be attempted as in the Wike House, largely by variation in window sizes (Fig. 121). Where such expansion is less developed, as in the Brant House (Figs. 122, 123), it is difficult for the contemporary work to stand up to Lutyens in semiological focus or plastic power, though its superior tension expands it in its

own peculiarly modern, taut, and anxious way. Yet one of the least "anxious" of the New Shingle Style architects, Jaquelin Robertson of Virginia, has already begun to revive the great classical details themselves in his high-podiumed, steep-stepped Madden Project of 1965 (Figs. 124, 125), over-scaling his simplified portico like Jefferson at Farmington, while his giant curved window at the rear prefigures Venturi's in the Wike House.

There are other problems involved in these questions at the moment. We recall, for example, that when most of the architects of the later eighties reacted against the Shingle Style it was toward the bright, light, geometric purity of more classicizing forms that they turned (Fig. 27). While writing *The Shingle Style* I was not immune to such feelings, and each night I found myself leafing through the early volumes of Le Corbusier's *Oeuvre Complète* with stupefied absorption. The thin, tense, hyperintelligent forms were apparently the relief I needed from shingle fuzz, plastic intersections, and infinite spatial variety (Figs. 126, 127). Today there are others who share such feelings, and who, exactly contemporary with the younger of the New Shingle Style architects, attempt to "misread," and to swerve from, Le Corbusier's forms of the 1920s. One leaves aside questions, which are otherwise fundamental, of suitability to American climate, durability, upkeep, and so on. Most of the neo-Corbusians are lost out in left field here (with my own house of 1950). But what we must ask is why even such an urbane stylist as Richard Meier (whose vast window in the Saltzman House is a contemporary of Robertson's) has not yet been able to convince us that the Villa Savoie, for example, is an immature version of his own work (Fig. 128). Indeed, no one can do so, because the Villa Savoie is a mature product of one of the most telling architectural intellects and talents of all time. It is a closed system, complete. Inside, it is the hermetic labyrinth of the mind, the special world of Cubism, of man-made forms pursuing the circuitous paths of intellectual

quest, infinitely overlapping. And that internal universe, that volume encased as in one of Leonardo's skulls by its thin external shell, is set in its exact opposite: in the Impressionist landscape, the world of nature loved for itself in the light that reveals it, Monet's world of empirical external reality. These two most contrasting and, beyond classicism, most true of French perceptions since Gothic days are thus juxtaposed by Le Corbusier, and served up by him in one complete and final Ile-de-France scene: no one, to say nothing of an American, can break into or out of it by swerving.

Perhaps that is one reason why Peter Eisenman, who is the most articulate and methodologically integrated of the so-called Five Architects, is careful to leave Le Corbusier alone and indeed claims for himself, with some justice, so hermetically involuted a method of design that he can escape from all influences, can indeed avoid being embedded in cultural relationships of any kind (Figs. 129, 130). Of course, no man can avoid his culture; even the instinct to do so is a cultural fact, while Eisenman's method, based on Chomsky's linguistic analysis, is clearly enough culture-derived. But Eisenman uses that device as his way of swerving—to Mars if necessary—and of clearing out a space for his own design. As Venturi sometimes does, he likes to make his buildings resemble models. True, his work was in part inspired by that of Terragni, but it is difficult to feel anxiety in that somewhat remote and cerebral connection, and the point remains.

On the other hand, perhaps some of the other Five Architects, obsessed with Le Corbusier, are not going after their precursor young enough. In that they might have done well to mark the research of their own historian, Colin Rowe, who wrote an article in 1950 about Le Corbusier's very early work in his Swiss home town of La Chaux-de-Fonds (Colin Rowe, "Mannerism and Modern Architecture," *Architectural Review*, May 1950). Rowe showed how the broad, central, blank surface with flanking windows of the facade of Le Corbusier's

Schwob Villa, of 1916, might be regarded as deriving from designs by Palladio (Fig. 131). Not published by Rowe, but presented for the first time by Warren Cox in *Perspecta, the Yale Architectural Journal, 6,* 1960, was Le Corbusier's Scala movie theatre in La Chaux-de-Fonds, which was much the same, though with a thin, arched frontispiece and square windows below it (Fig. 132). The Five Architects did not turn toward these designs: precisely, one presumes, because they were not examples of Le Corbusier's mature "white" architecture of the twenties, the center of historical attention since that time and the model of reality for subsequent generations. But Venturi, more capable than they of freeing himself from preconceptions, and perhaps with a keener instinct for the precursor's jugular, did do so. His Guild House of 1960–63, so venomously despised by part of the profession (about as viciously as Le Corbusier's own work once was), is clearly a recombination of those two of Le Corbusier's early designs, from the central void to the thin-arched frontispiece, the square windows, and the large-scaled round pier below (Fig. 133). Even the supergraphics. How upsetting for Le Corbusier's self-appointed heirs to discover that the hoodlum from Philadelphia had met their daddy at the crossroads long before, and might even—an old American fantasy—turn out to be the Dauphin after all.

It is surely one of the historian's dirtiest, least demanding, and most satisfying of revenges to be able to point connections like this out—to say nothing, one might add, of the common relation of the Guild House and the Schwob Villa to Lutyens (Fig. 119): published in 1914 and probably a more direct influence on Le Corbusier in this instance than Palladio was. Still, with calm, and if everyone will henceforward keep a civil tongue in his head, a dialogue fruitful for the doubtful future may yet be possible between the competing schools. Everyone has a good deal to tell everyone else; the issues are real ones. The problem of mass housing, under a selfish administration,

calls always, and not only from the cities. Rural America is an agony inadequately recognized. And here the "inclusive" approach of the Shingle Style vernacular may yet find its proudest programs and so fulfill the hopes, as stated by Stevens and Cobb, of its nineteenth century progenitors. But beyond and embracing all such considerations is the problem of man and Fate, of human construction in the face of Nature, with her pimping attendant Time, whom the American architects, isolated as they are like lumberjacks on this violent continent, have perhaps had occasion to know more nakedly than their European contemporaries do. The Trubek and Wislocki houses embody this too, humbly, boldly, and well. (Fig. 134). Here is the other side of the Emersonian vision, where "nature is something mocking," and where "If we measure our individual force against hers we may easily feel as if we were the sport of an insuperable destiny." So Stevens's strong poet hears the roaring of the northern lights in the cold night sky above his head and resolves, in the teeth of everything, to face them down:

> This is nothing until in a single man contained,
> Nothing until this named thing nameless is
> And is destroyed. He opens the door of his house
> On flames. The scholar of one candle sees
> An arctic effulgence flaring on the frame
> Of everything he is. And he feels afraid.

"But," Emerson goes on, "if instead of identifying ourselves with the work, we feel that the soul of the Workman streams through us, we shall find the peace of the morning dwelling first in our hearts. . . ." It was surely some such agony of pride and submission, of terror and transcendence, that set the little houses out in the vastness of this continent in the first place, and kept them there. It seems irrelevant to build in America anything which is less than this vision, or to discuss it in terms which are any less demanding.

It can be no accident that the impulses which created the new Shingle Style caught fire when they did—at a time when so many Americans, especially the young, were seeking to escape from city and suburb alike in order to try to dig back down to the roots of American decency once more. If, unlike their spiritual ancestors of the nineteenth century, the best of them have tempered romanticism with irony, they were still reacting like them to the brutal realities of urbanism and government during a particularly ugly epoch. They too were trying to tap the resources of the American spirit and to release its soul; and indeed "the soul of the Workman," the genius of the place, has clearly responded to them, if only by a little. So invoked, it may well stand forth again and again in difficult times; to renew us, as in 1876 and the 1970s, in times of shame.

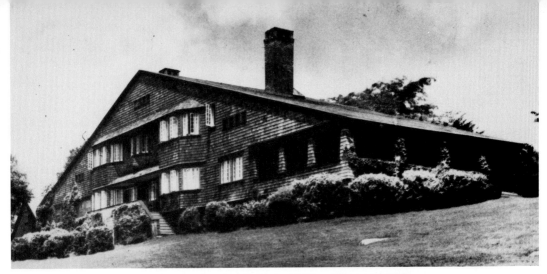

1 W. G. Low House, Bristol, Rhode Island, by McKim, Mead and White,
 1887. Demolished by a later owner who built himself a ranch house
 on the site.

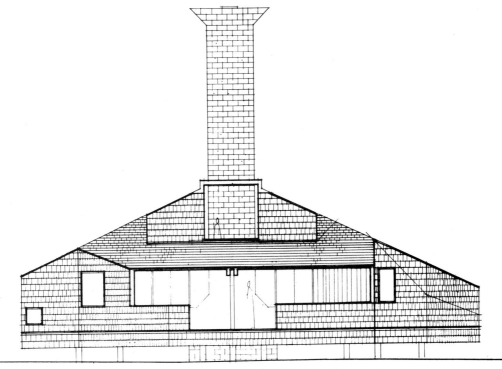

2 Project for a Beach House, by Robert Venturi, 1959. Elevation drawing.

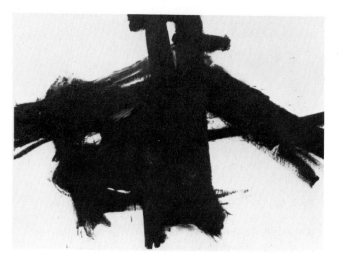

3 *Crosstown*, oil on canvas, by Franz Kline, 1955.

4 Watts Sherman House, Newport, Rhode Island, by Henry Hobson Richardson, 1874–76. Before additions.

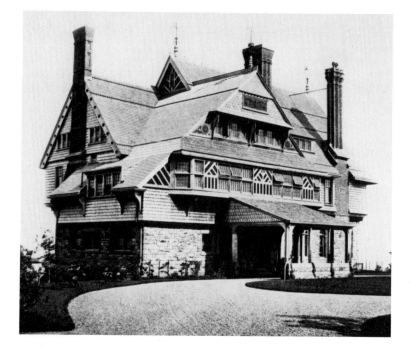

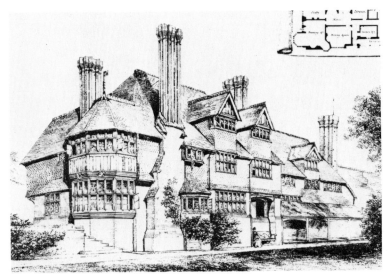

5 "Hopedene," Surrey, by Richard Norman Shaw, 1874.

6 Bishop Berkeley House, Middletown, Rhode Island, 1728. As published in *The New York Sketch Book of Architecture*, v.1, 1874.

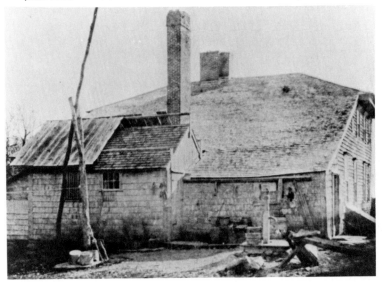

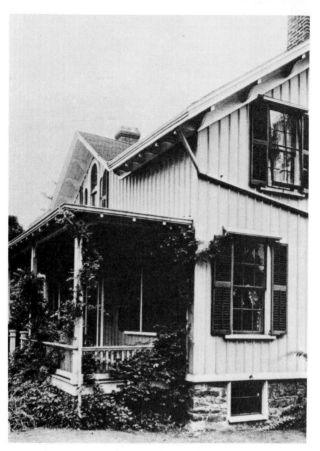

7 Board and Batten House, Newport, Rhode Island, c. 1845.

8 Sturtevant House, Middletown, Rhode Island, by Dudley Newton, 1872.

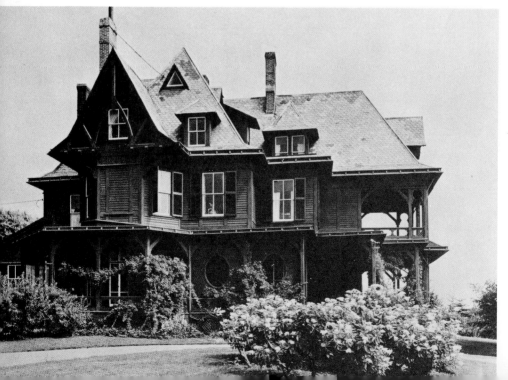

9 Watts Sherman House. Living Hall. Perspective by Stanford White.

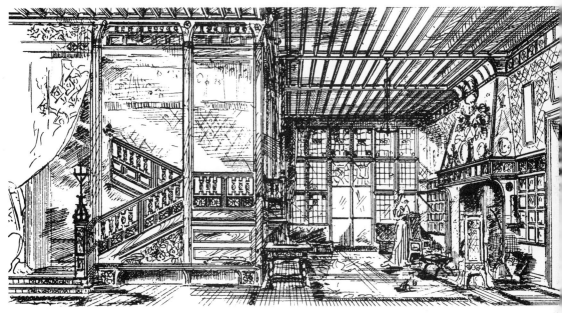

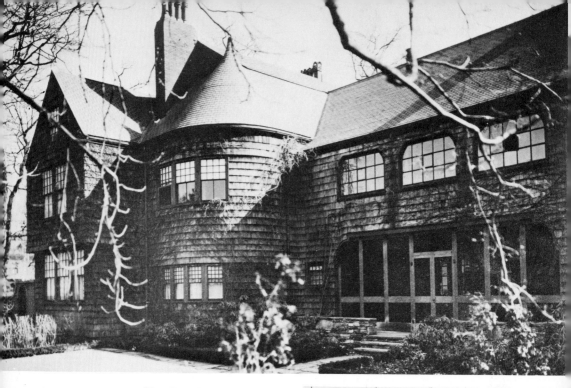

10 Stoughton House,
Cambridge, Massachu-
setts, by Henry Hobson
Richardson, 1882–83.

11 Stoughton House. Plan.

12 Fairbanks House,
Dedham, Massachusetts,
c. 1637, with eighteenth-
century additions.

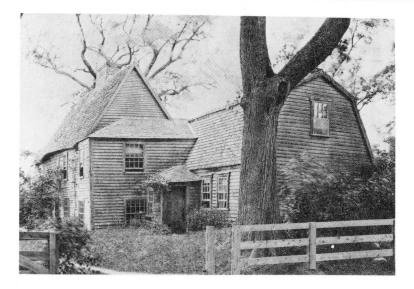

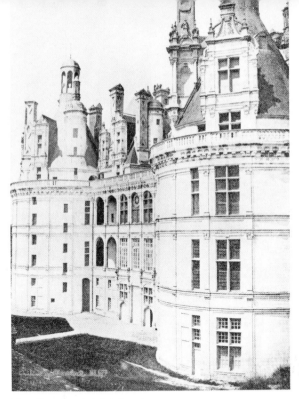

13 Chambord. The Court.

14 Palazzo Ducale, Urbino. Fifteenth century.

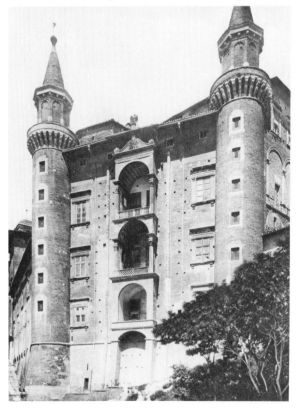

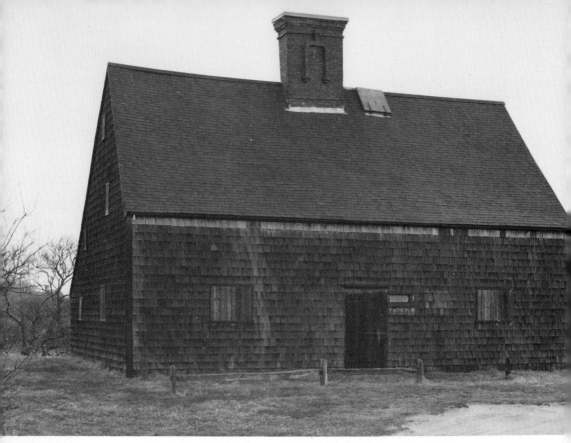

15 Jethro Coffin House, Nantucket, Massachusetts, 1686.

16 Old Wind Mill, Nantucket, Massachusetts, 1746.

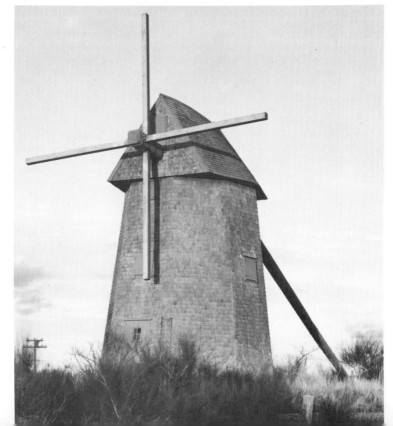

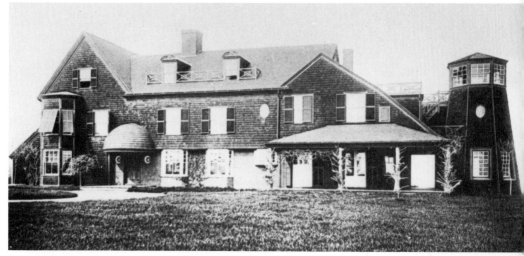

17 "Grasshead," the James L. Little House, Swampscott,
Massachusetts, by Arthur Little, c. 1882.

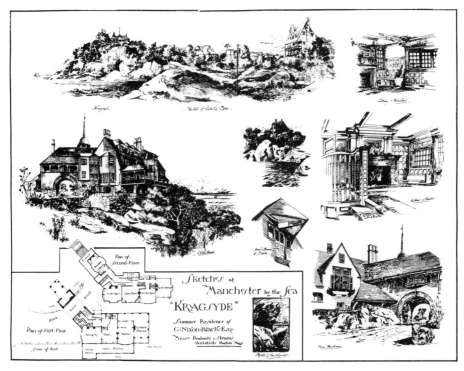

18 "Kragsyde," the G. N. Black House, Manchester-by-the-Sea,
Massachusetts, by Peabody and Stearns, c. 1882–83.
Sketches by E. Eldon Deane in *American Architect and
Building News*, 1885.

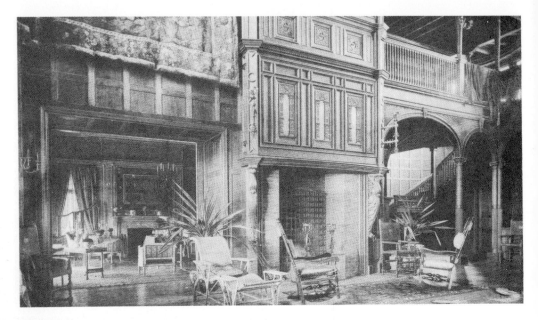

19 Robert Goelet House,
 Newport, Rhode Island, by
 McKim, Mead and White,
 1882–83. Living Hall.

20 Nakamura Villa, Nara,
 Japan. Tokonoma.

21 Newport Casino, by McKim,
 Mead and White, 1880–81.
 Piazza.

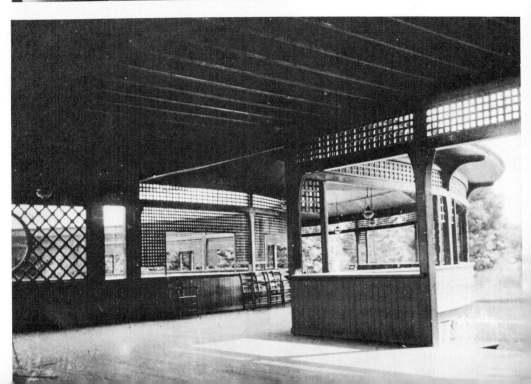

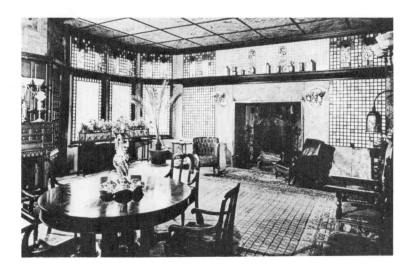

22 "Kingscote," Newport, Rhode Island. New Dining Room by Stanford White, 1880–81.

23 Tilton House, Middletown, Rhode Island, by McKim, Mead and White, 1882. Living Hall.

24 Frank Lloyd Wright House, Oak Park, Illinois, 1889. Living Room.

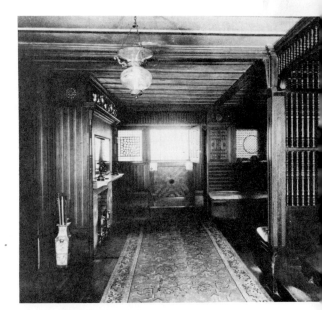

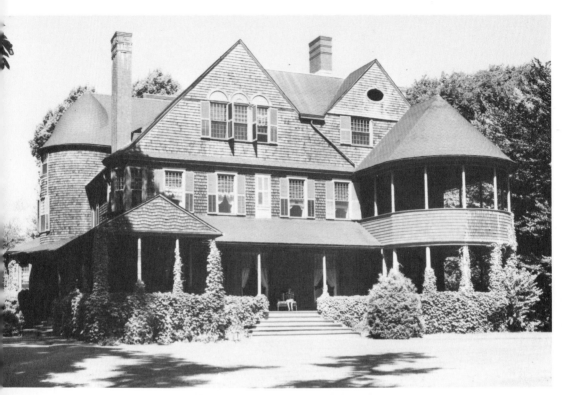

25 Isaac Bell House, Newport, Rhode Island
 by McKim, Mead and White, 1882.

26 Isaac Bell House. Plan.

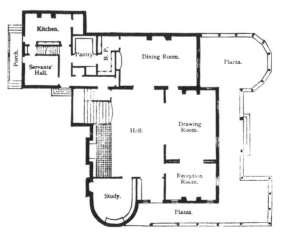

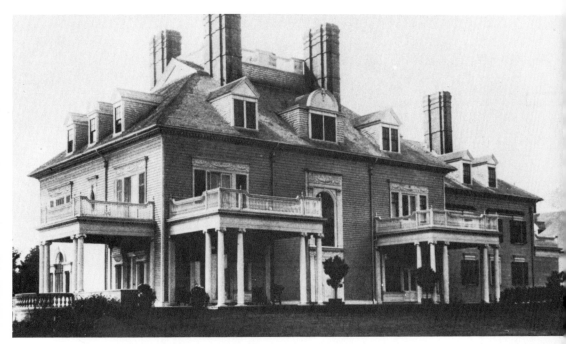

27 H. A. C. Taylor House, Newport, Rhode Island, by McKim, Mead and White, 1885–86. Demolished.

28 H. A. C. Taylor House. Plan.

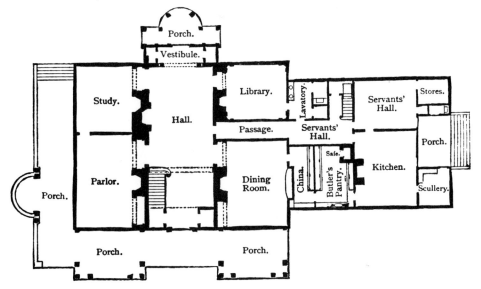

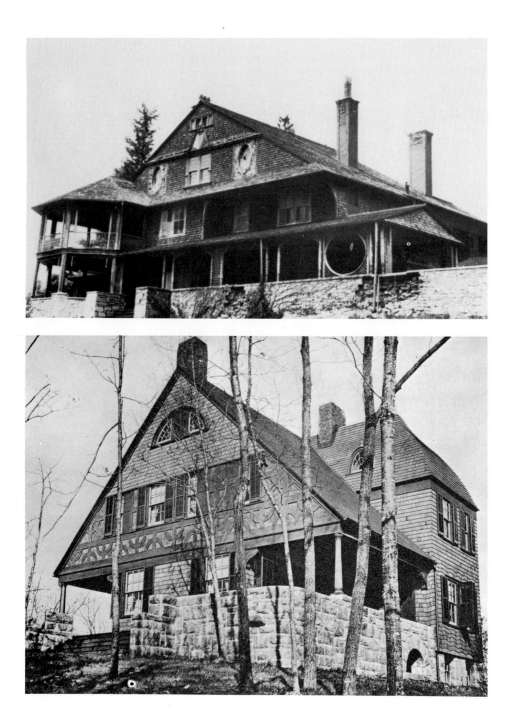

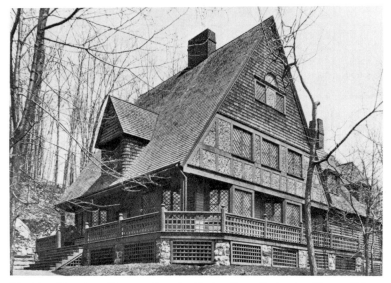

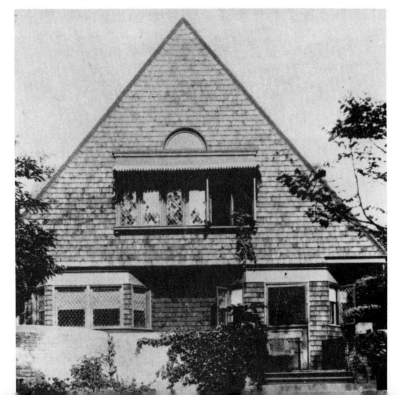

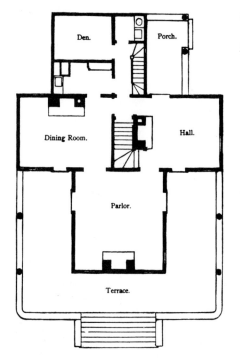

33 Kent House.
 Plan.

34 Ward Willitts House.
 Plan.

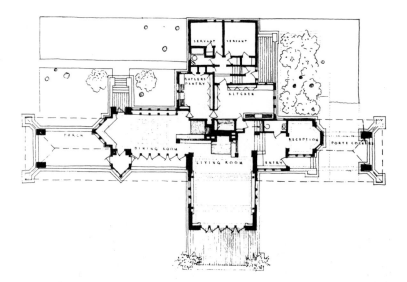

35 Ward Willitts House, Highland Park, Illinois, by Frank Lloyd Wright, 1900–02.

36 Ward Willitts House. Side elevation, as published by Wasmuth, Berlin, 1911, in, *Frank Lloyd Wright: Ausgeführte Bauten*, p. 59.

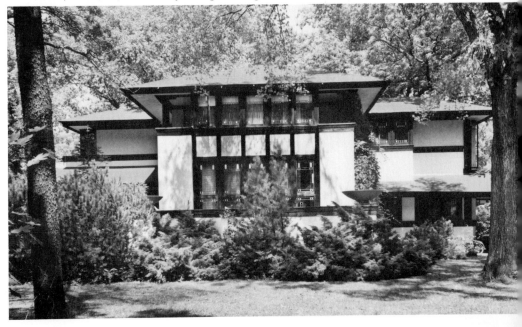

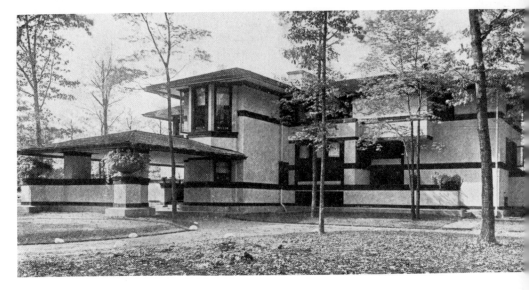

37 V. J. Scully House, Woodbridge, Connecticut, 1950. Living Area.

38 Bracketed Veranda from Andrew Jackson Downing, *Country Houses,*
 1853.

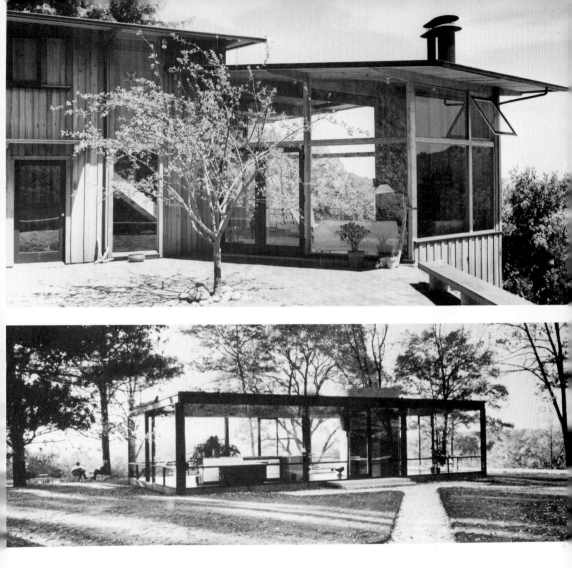

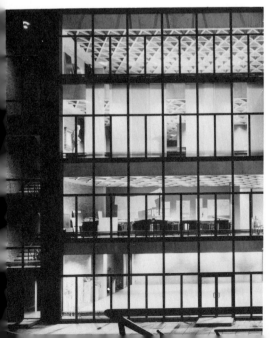

39 Lawrence Halprin House,
Kent Woodlands,
California, by Bernardi
and Emmons, 1952.

40 Philip Johnson House,
New Canaan,
Connecticut, 1949.

41 New Art Gallery, Yale
University, by Louis I.
Kahn and Douglas Orr,
1953. View from Weir
Courtyard at night.
Progressive Architecture,
May, 1954, p. 92

42 Bath House, Trenton, New Jersey, by Louis I. Kahn, 1955.

43 Charles W. Moore House, Orinda, California, 1962.

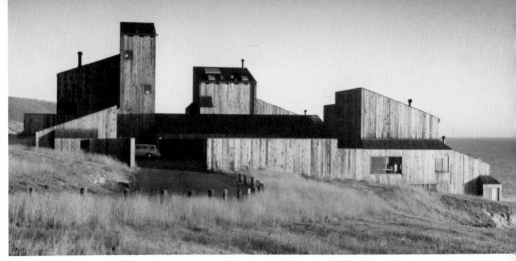

44 Condominium, Sea Ranch, California, by Charles Moore, 1965–66.

45 Civic Center, Saynatsalo, Finland, by Alvar Aalto, 1950–51.

46 House at Stommeerkade, Aalsmeer, Holland, by Bijvoet and Duiker, 1924.

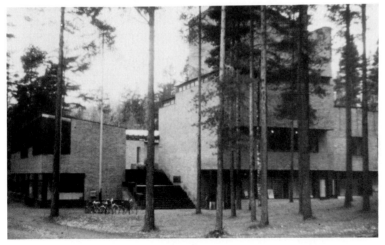

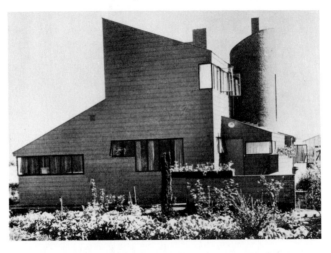

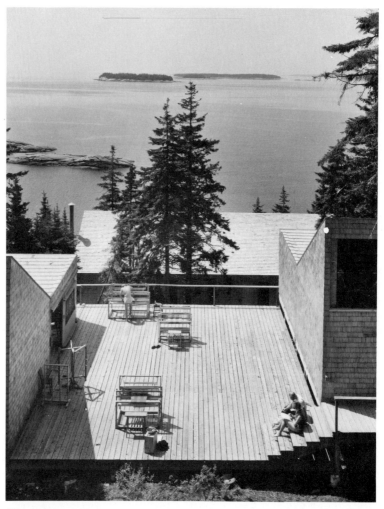

47 Haystack Mountain School of Crafts, Maine, by Edward Barnes, 1962.

(*opposite*)
48 Sea Ranch under construction.
49 Sea Ranch. Interior.

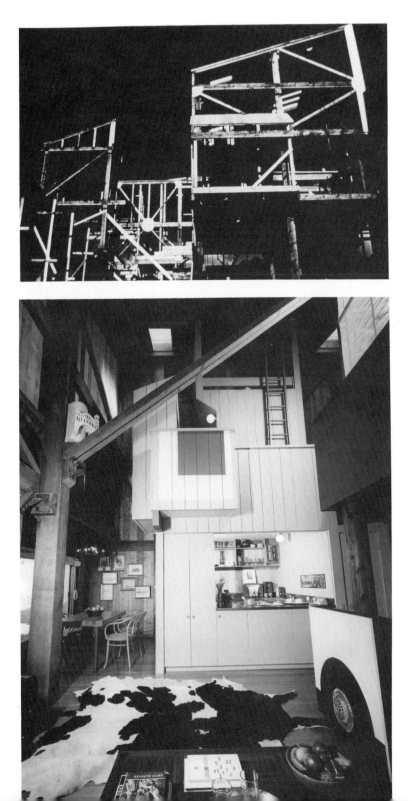

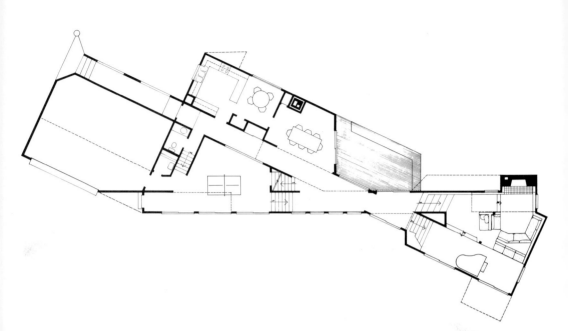

50 Stern House, Woodbridge, Connecticut, by Charles Moore, 1971.
 Plan.

51 Stern House. Interior.

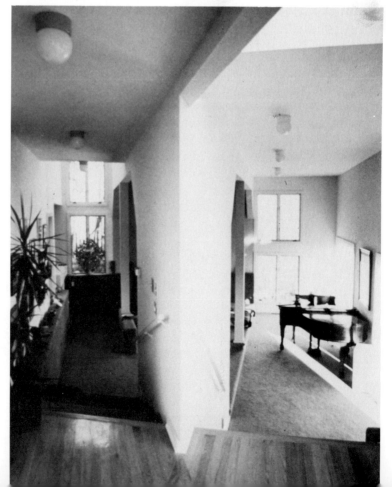

GROUND FLOOR PLAN

52 Klotz House, Westerly, Rhode Island, by Charles Moore, 1969. Plan.

53 Chandler House, Tuxedo Park, New York, by Bruce Price, 1885–86. Plan.

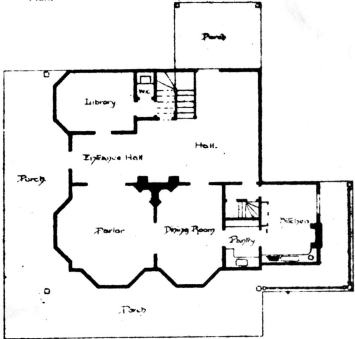

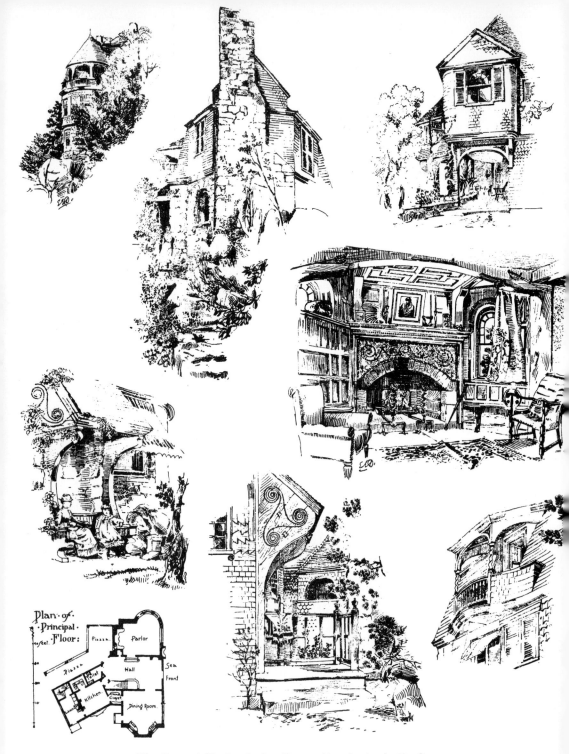

54 General Charles Loring House, Manchester-by-the-Sea, Massachusetts, by William Ralph Emerson, 1882–83. Renderings by E. Eldon Deane in *American Architect and Building News*, 1884.

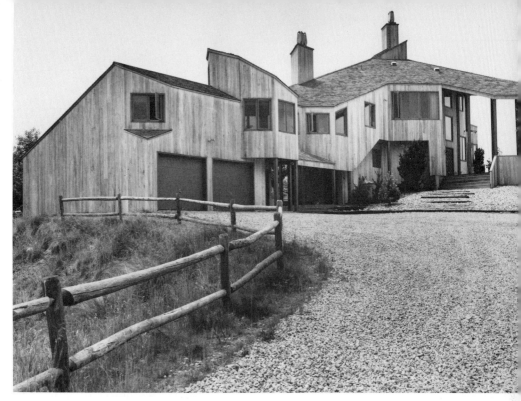

55 P. M. Klotz House, by Charles Moore, 1970–71.

56 "Kragsyde," the G. N. Black House, Manchester-by-the-Sea, Massachusetts, by Peabody and Stearns, 1882–83.

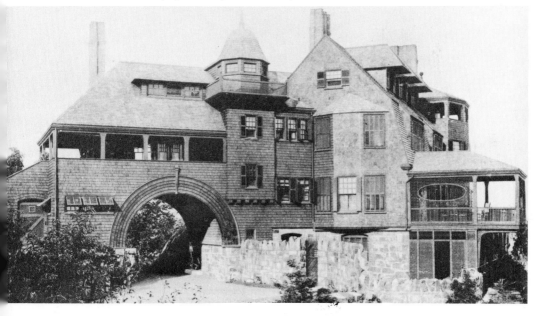

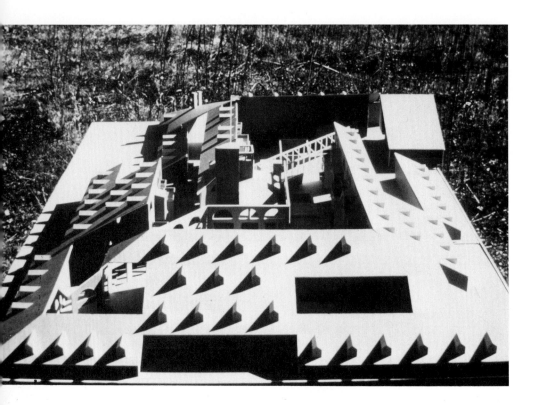

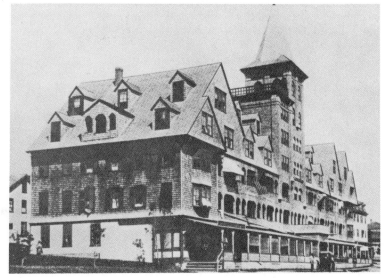

(opposite)

57 Project for a Resort Hotel, St. Simon's Island, Georgia, by Charles Moore, 1972–73. Model.

58 Hotels Thorndike and Bayview *(in the rear)*, Jamestown, Rhode Island, c. 1885.

59a Project for Resort Hotel. Interior. View of model.

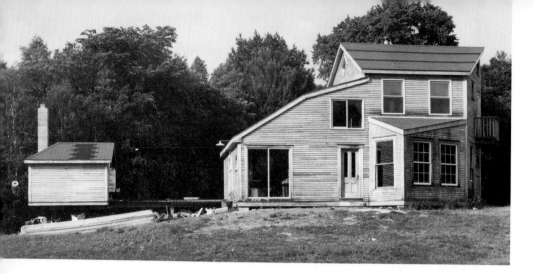

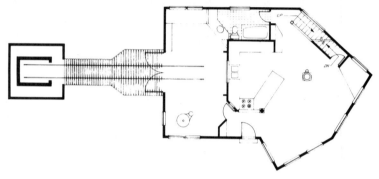

59b Caroline Glazebrook House, Starksboro, Vermont, by Turner Brooks (with Peter Laffin and Mike Burgess, builders), 1972.

59c Glazebrook House. Plan. A truck carrying the ceramics and the door of the kiln runs on a track from the studio.

59d Glazebrook House. Living Room.

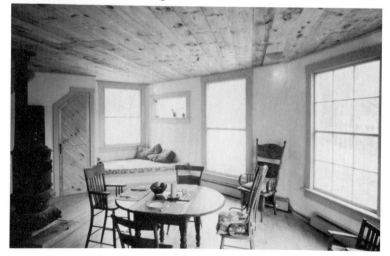

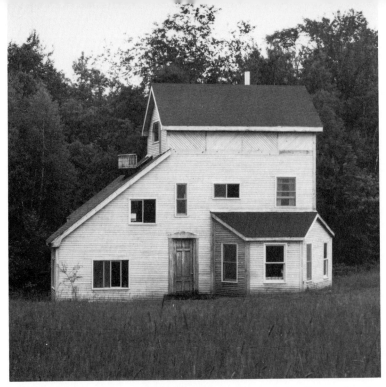

59e Evelyn Butterworth House, Starksboro, Vermont, by Turner Brooks
(with Peter Laffin and Mike Burgess, builders), 1973.

59f Willis Higgins House, Starksboro, Vermont, by Turner Brooks (with
Peter Laffin and Mike Burgess, builders), 1973–74.

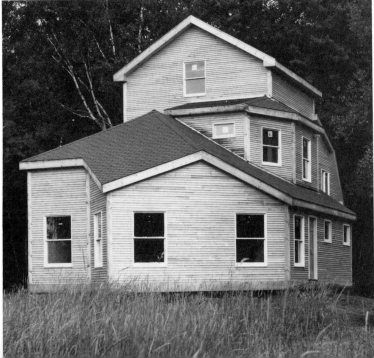

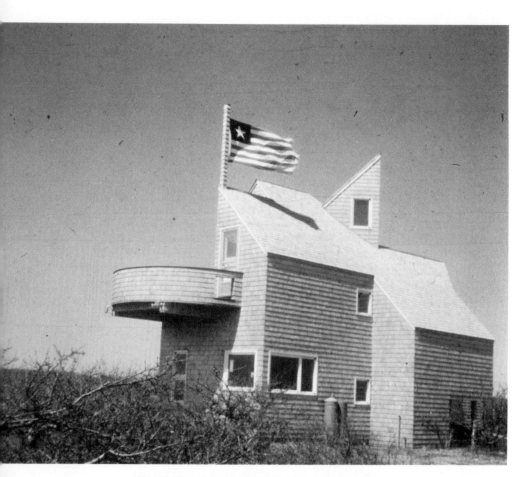

60 Hadley House, Martha's Vineyard, Massachusetts, by Hardy, Holzmann and Pfeiffer, 1968.

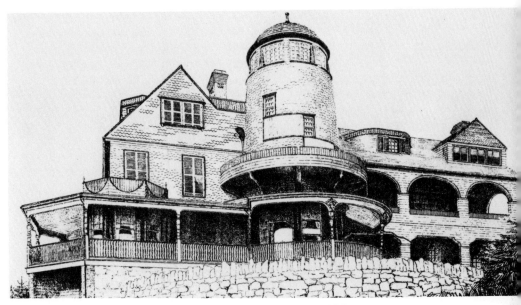

61 House at Bar Harbor, Maine, by William Ralph Emerson, 1885.

62 Fisherman's House, seventeenth-century type, Siasconsett, Nantucket, Massachusetts.

63 Shingle Style House, Siasconsett.

64 Hadley House.

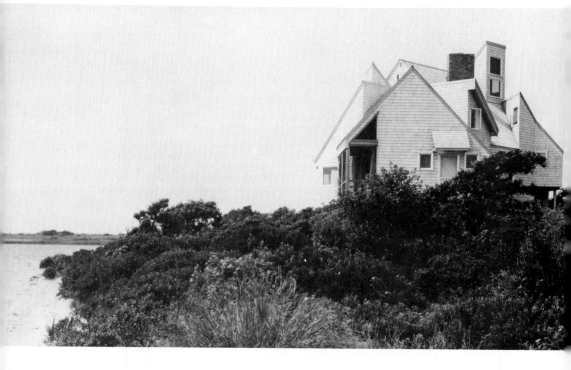

(opposite)

65 A residence in Minnesota, by Romaldo Giurgola; Steven Goldberg, project architect, 1970. View from southeast.

66 John Nicholas Brown House, Fisher's Island, New York, by Richard Neutra, 1938. Destroyed by fire, 1973.

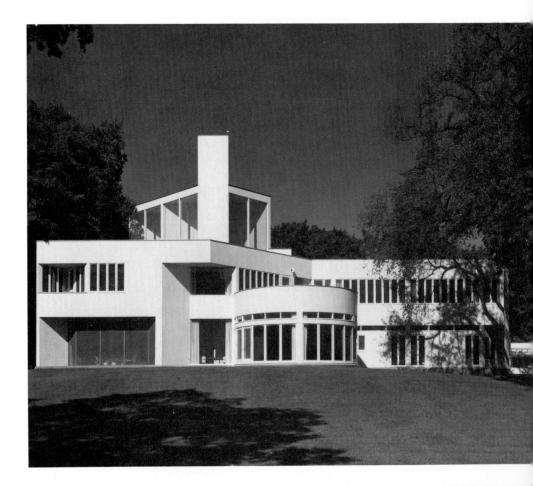

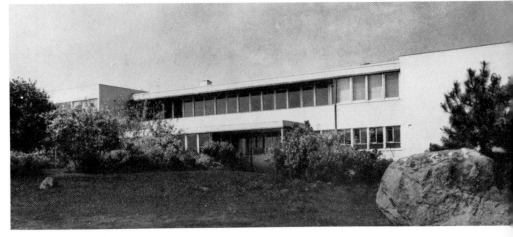

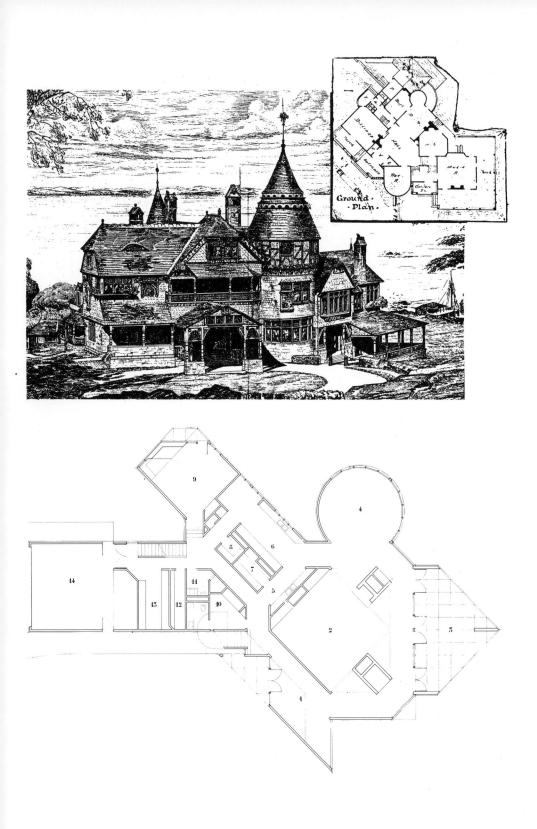

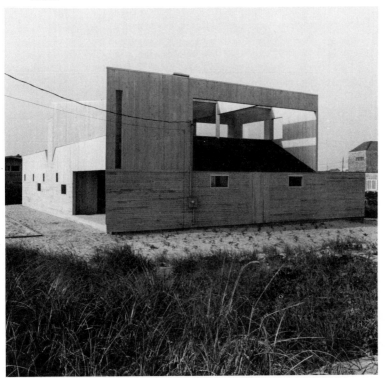

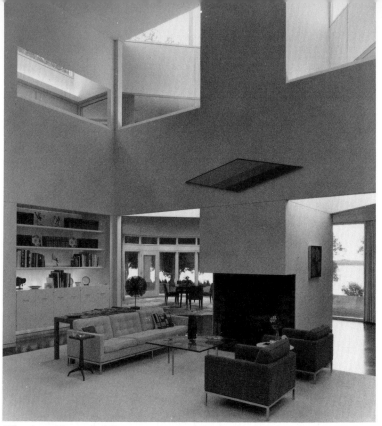

70 A residence in Minnesota. Living Room.

71 Maison La Roche, Auteuil, by Le Corbusier, 1923.

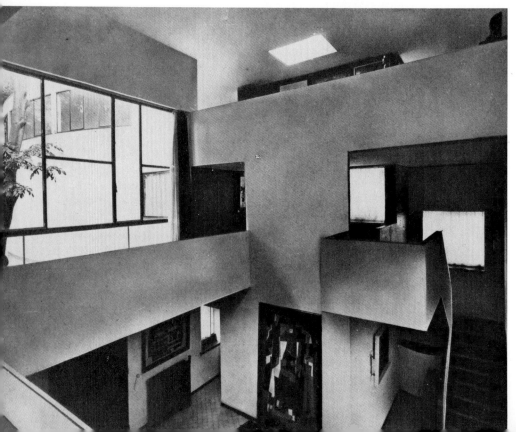

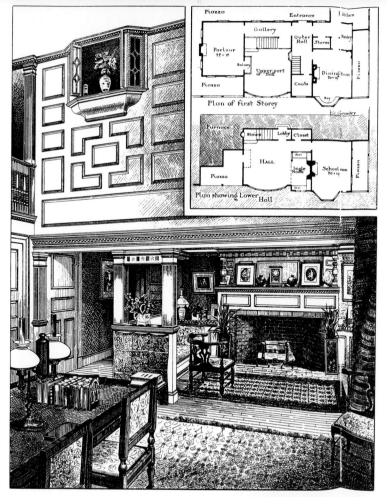

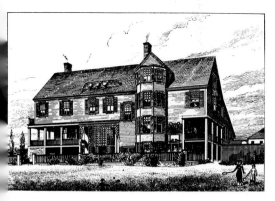

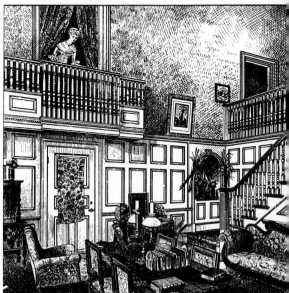

72 "Shingleside," Swampscott,
Massachusetts, by Arthur Little,
1881.

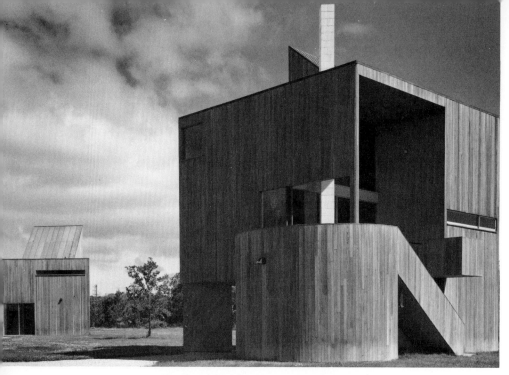

73 Robert Gwathmey House and Studios, Amagansett, New York, by Charles Gwathmey and Robert Siegal, 1966–67.

74 Gwathmey House. Plan.

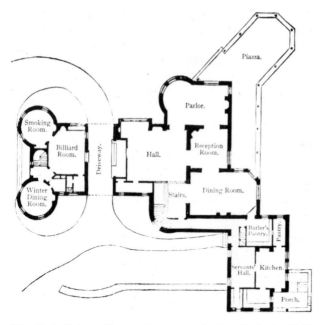

75 C. J. Osborn House, Mamaroneck, New York, by McKim, Mead and White, 1884–85. Plan.

76 "Citrohan" House, Weissenhof Housing, Stuttgart, Germany, by Le Corbusier, 1927.

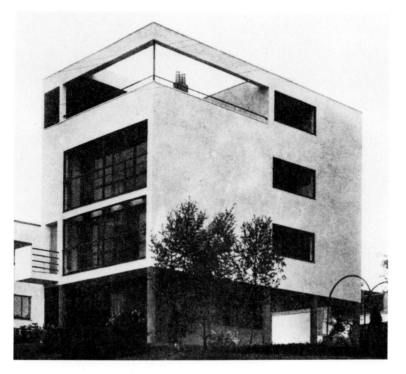

77 Gwathmey House. Studios.

78 Vacation house for Dr. and Mrs. Alan Grey, Wellfleet, Massachusetts, by Giovanni Pasanella, 1967.

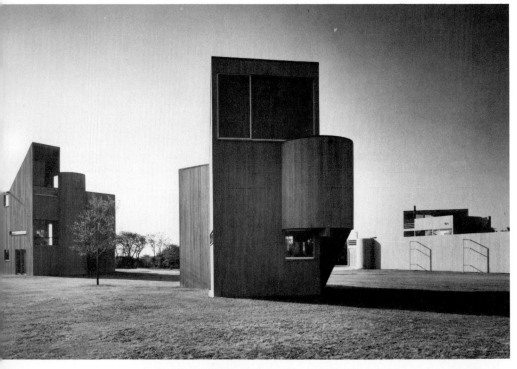

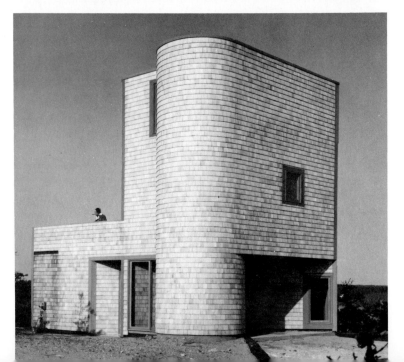

79a Alan Grey House. Isometric
 drawing by Thomas Stetz.

79b Houses at Long Beach
 Island, New Jersey, by
 Murphy-Levy-Wurman, 1969.

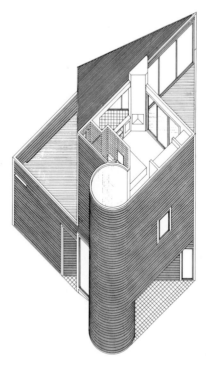

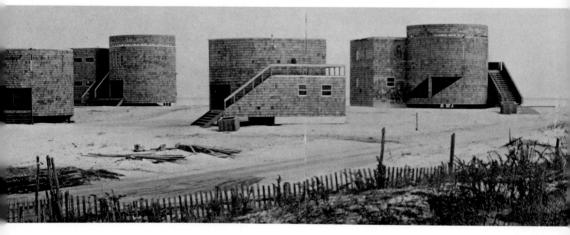

80 Seltzer House, Sagaponack, New York, by Jaquelin T. Robertson, 1966–67.

81 Seltzer House. Porch.

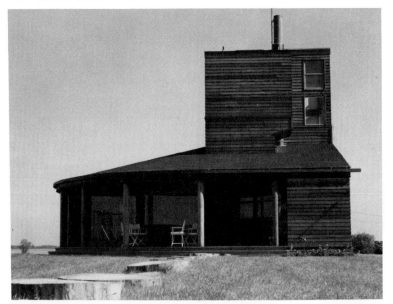

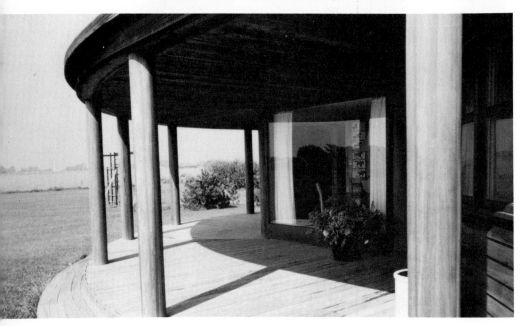

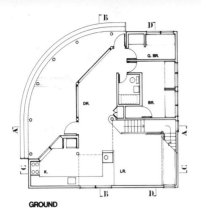
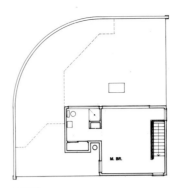

GROUND SECOND

82 Seltzer House. Plan.

83 Seltzer House. Stair Hall.

84 Seltzer House. View of sea side.

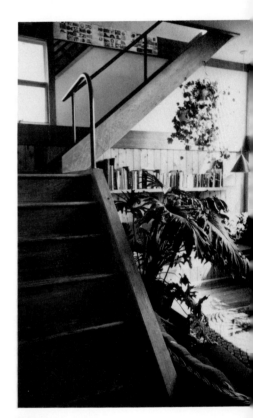

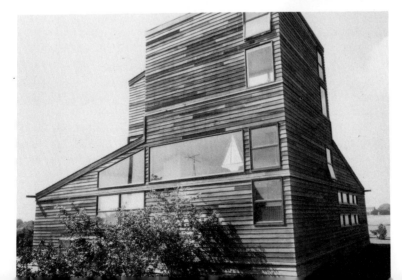

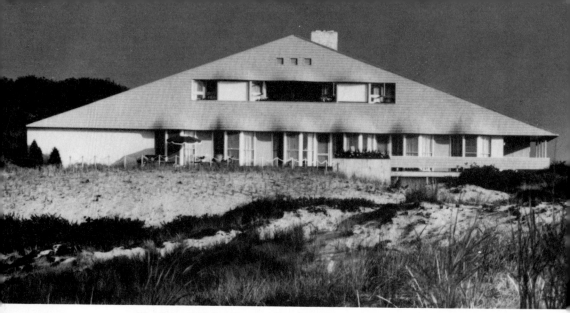

85　Otto Spaeth House, East Hampton, New York, by Nelson and Chadwick, 1957.

86　Otto Spaeth House.　Detail.

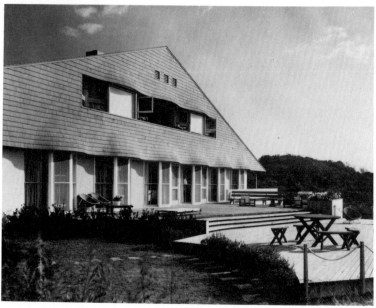

(opposite)
87　Project for a Beach House, by Robert Venturi, 1959.　View of model.

88　Project for a Beach House.　Plan.

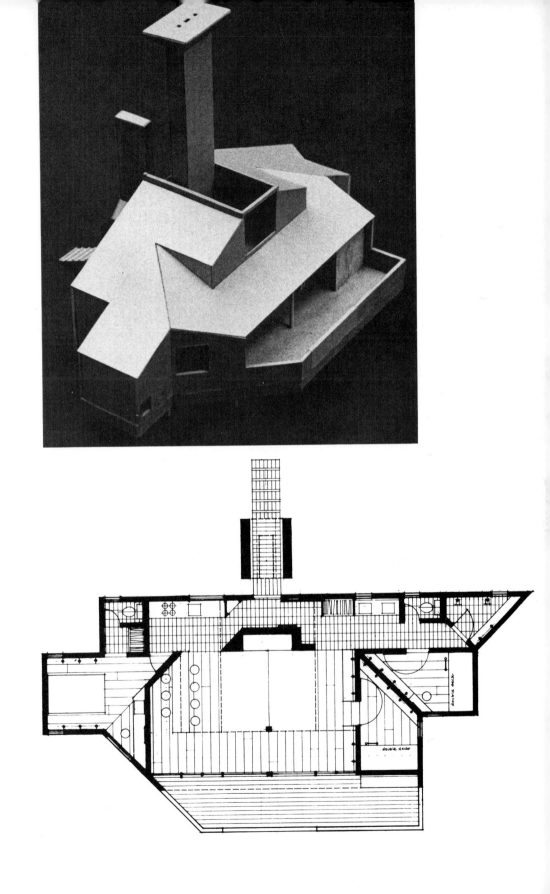

double deck

double deck

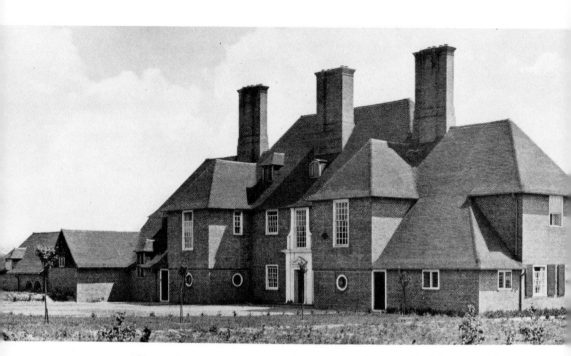

89 Middlefield, Great Shelford, Cambridgeshire, England, by Sir Edwin Lutyens, 1908.

90 "Stratford," the Lee Mansion, Westmoreland County, Virginia, c. 1725.

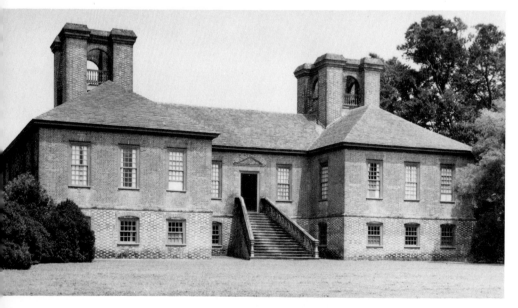

91 House in Canada, by Richard Weinstein, 1972.

92 Project for Jenkins House, St. Helena, Napa Valley, California, by Charles Moore, 1961. View of model.

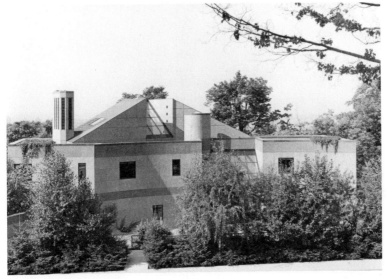

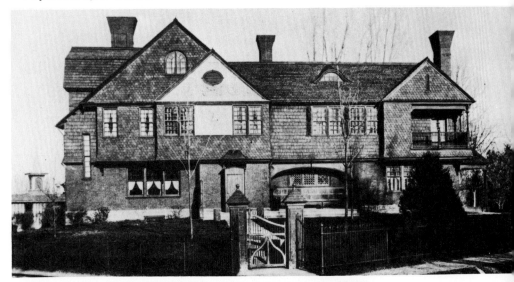

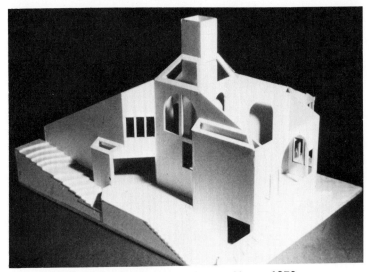

96 Project for Goodman House, by Charles Moore, 1970. First scheme. View of model.

97 Project for Millard Meiss House, by Venturi and Short, 1962.
First scheme. View of model.

98 D'Agostino House Project, by Venturi and Rauch, 1968.
View of model.

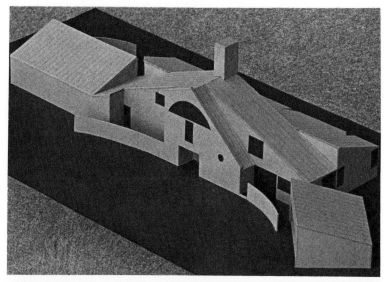

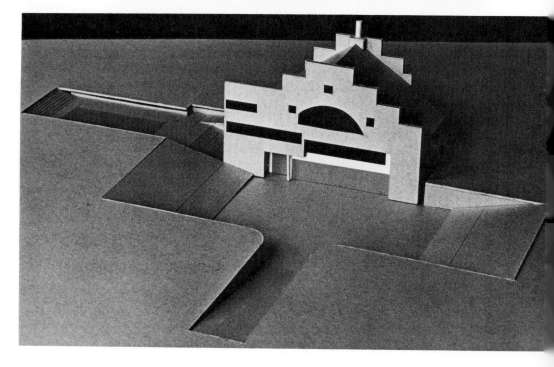

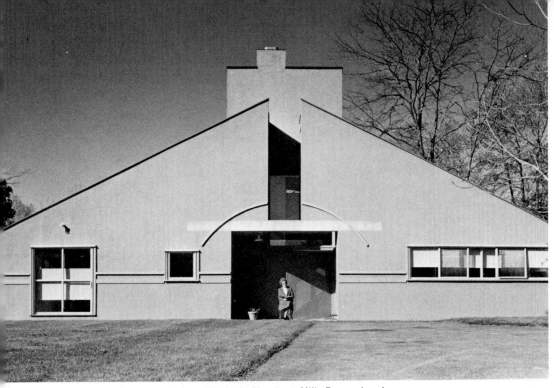

99 House for Mrs. Robert Venturi, Chestnut Hill, Pennsylvania,
by Venturi and Short, 1962–64. Entrance facade.

100 Venturi House. Plan.

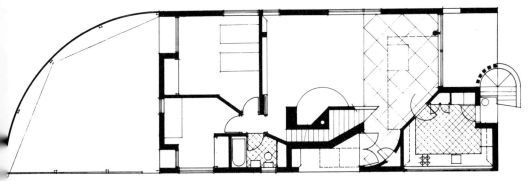

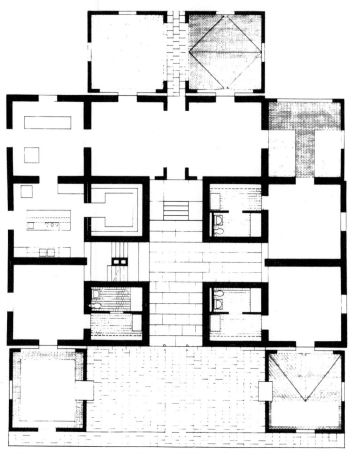

101 Project for Fleisher House, 1959, by Louis I. Kahn. Plan.

102 Charles A. Potter House, Chestnut Hill, Pennsylvania,
 by Wilson Eyre, c. 1884–86. Plan.

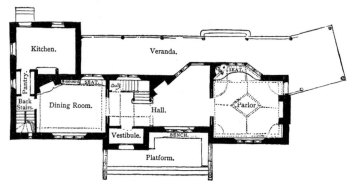

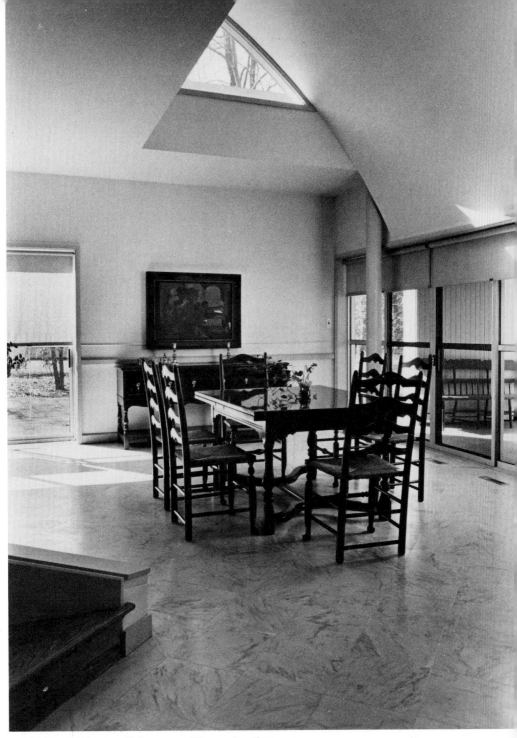

103 Venturi House. Dining area with coved ceiling.

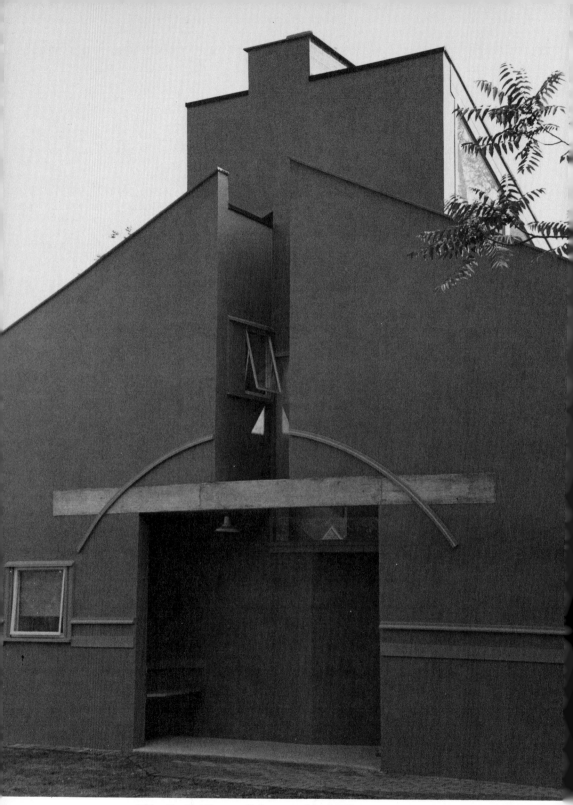

104 Venturi House. Entrance gable detail.

105 Venturi House. Upstairs bedroom.

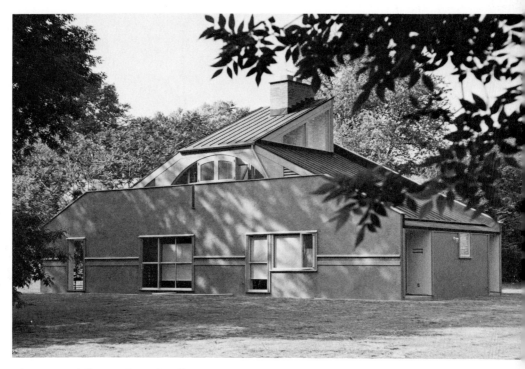

106 Venturi House. Rear elevation.

107 Wiseman House, Montauk, New York, by Stern and Hagmann, 1966–67.

108 Wiseman House. Plan.

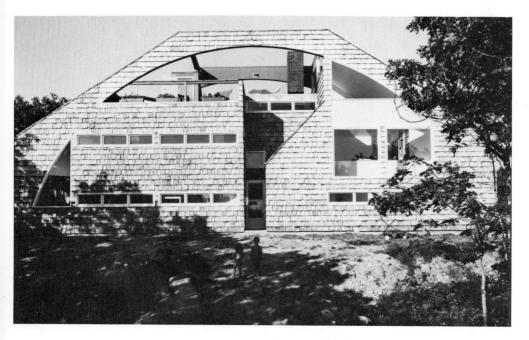

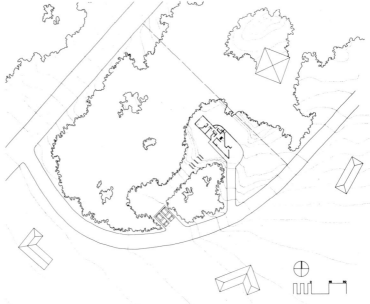

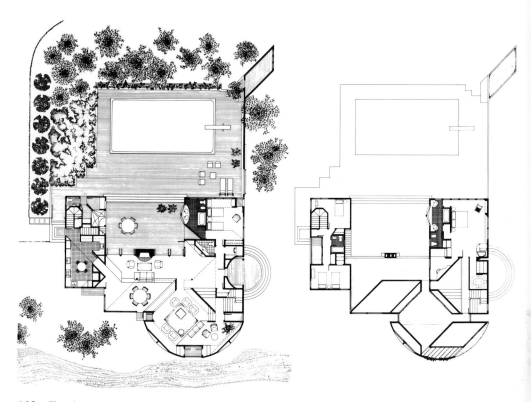

109 Two house grouping, Eastern Long Island, by Stern and Hagmann, 1972. Plan of main house.

110 E. D. Morgan House, Newport, Rhode Island, by McKim, Mead and White, 1888–91. Plan.

111 House on Eastern Long Island. Interior.

PLAN OF FIRST FLOOR

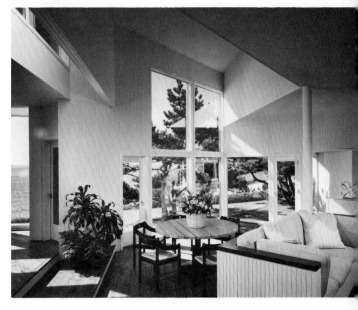

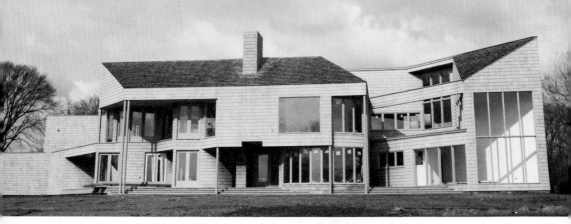

112 Saft House, East Hampton, New York, by Stern and Hagmann, 1973. Sea side, under construction.

113 Robert A. M. Stern House, East Hampton, New York, 1906. Renovations and additions, 1969.

114 C. A. Brown House, Delano Park, Maine, by John Calvin Stevens, 1885–86. Detail.

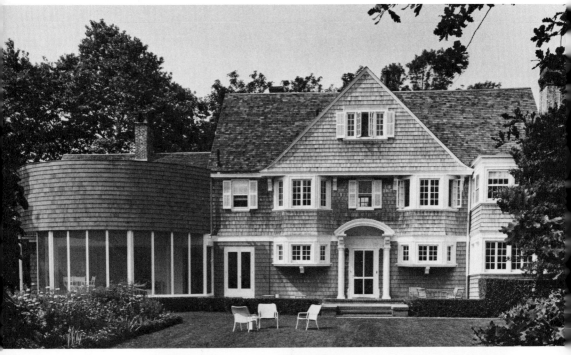

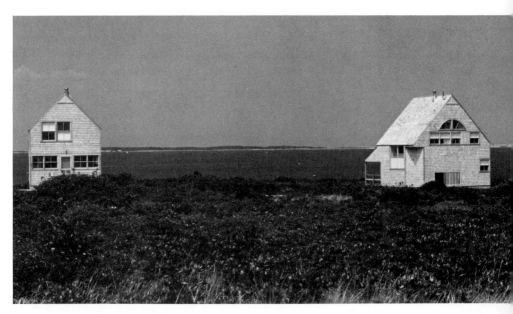

115 Trubek (*right*) and Wislocki Houses, Nantucket, Massachusetts,
by Venturi and Rauch, 1971–72. View in landscape.

116 Temple of Athena, Paestum.

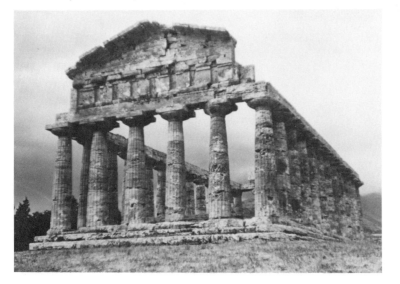

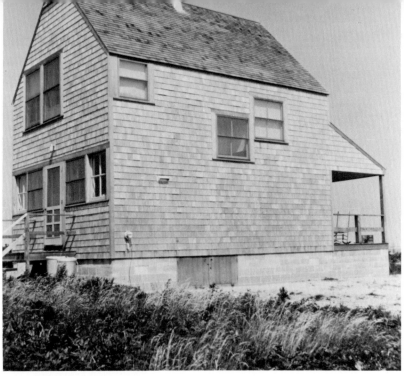

(*above and above right*)

117 Trubeck and Wislocki Houses. Composite view from between them.

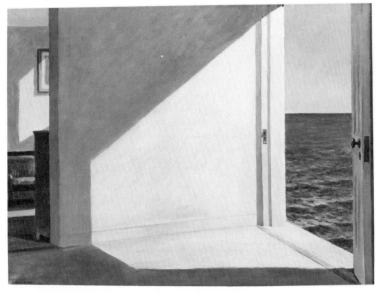

118 *Rooms by the Sea*, by Edward Hopper, 1951.

(*opposite*)

119 Heathcote, Ilkley, by Sir Edwin Lutyens, 1906.

120 Heathcote. Plan.

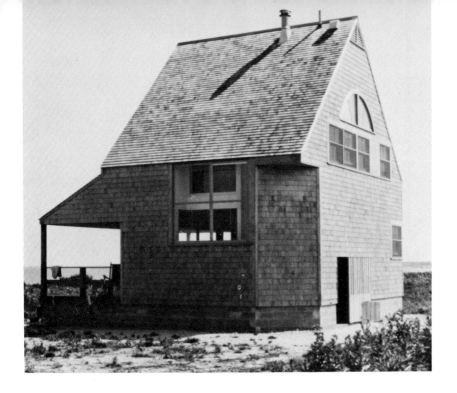

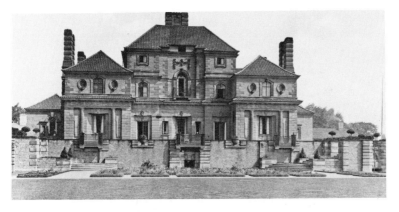

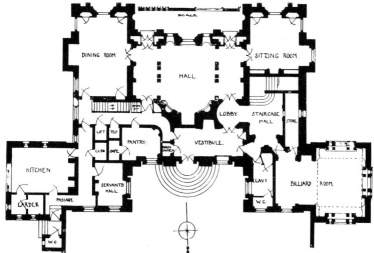

121 Wike House, Project, by Robert Venturi, 1969. View of model.

122 Brant House, Greenwich, Connecticut, by Robert Venturi, 1971. View from the south.

123 Brant House. Plans.

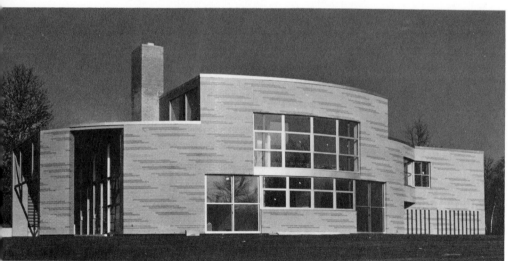

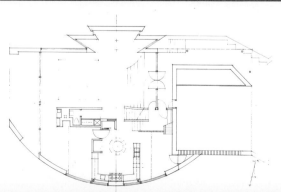

124 Madden House, project for Virginia, by Jaquelin Robertson, 1965. Portico.

125 Madden House. Monumental window.

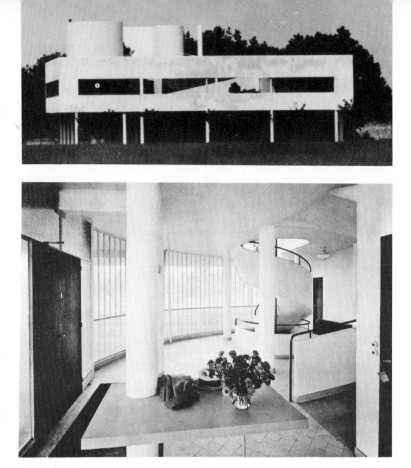

126 Villa Savoie, Poissy-sur-seine, by Le Corbusier, 1929–31.

127 Villa Savoie. Entrance Hall.

128 Renny Saltzman House, East Hampton, New York,
by Richard Meier, Architect, 1965.

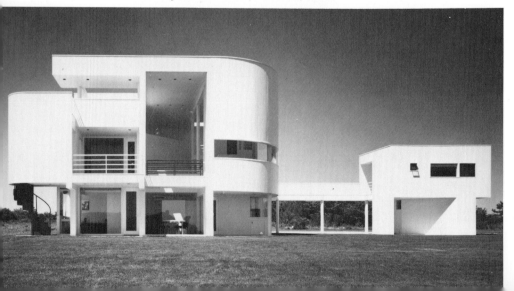

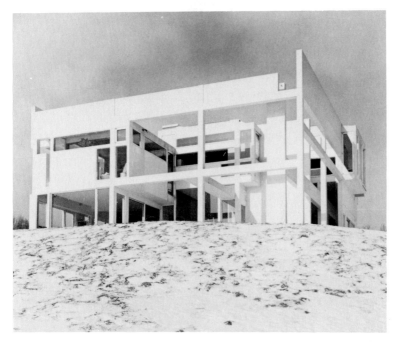

129 Falk House, Hardwick, Vermont (Cardboard Architecture House II), by Peter Eisenman, 1969–70.

130 Falk House. Isometric drawing.

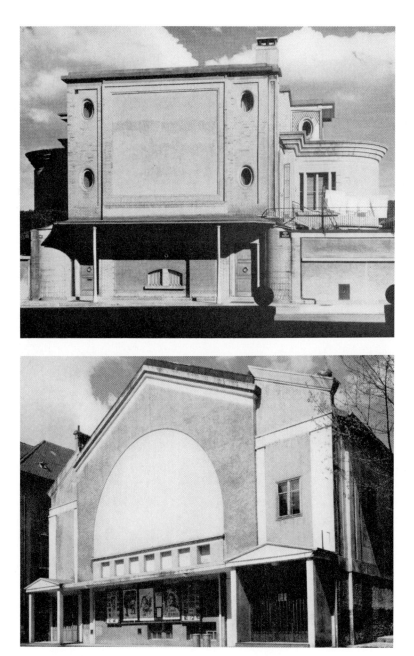

131 Villa Schwob, La Chaux-de-Fonds, Switzerland,
by Le Corbusier, 1916.

132 La Scala Movie Theatre, La Chaux-de-Fonds, 1912–16,
by Le Corbusier.

133 Guild House Apartments for the Elderly, Philadelphia, Pennsylvania,
 by Venturi, Rauch, and Associates, 1960–63.

134 Trubek and Wislocki Houses. Composite view from sea side.

INDEX

Boldfaced numbers refer to figure numbers.

SOURCES OF ILLUSTRATIONS

Alinari: 14
American Architect and Building News, Boston and New York, 1879: 67;
 1881: 12; 1884: 54; 1885: 18
Wayne Andrews: 25, 35, 36, 39, 55, 90
D. Appleton et al, *Artistic Houses*, New York, 1883–84: 19
Les Archives Photographiques: 13
Architecture, New York, 1900–36: 31
Morley Baer: 43, 44, 49
Erik Borg: 59b, c, e, f
The Builder (magazine), London, December 25, 1886: 61
Building, A Journal of Architecture, v. 5, no. 12, New York: September 18,
 1886: 53
Building News and Engineering Journal, London: April 26, 1882: 72;
 1874: 5
W. King Covell, Newport, Rhode Island: 7, 8, 23
Downing and Scully, *Architectural Heritage of Newport, Rhode Island*,
 Cambridge, Mass., 1952: 4
John Ebstel, New York: 42
Peter Eisenman, courtesy of: 129, 130
Lionel Freedman: 41
Y. Futagawa: 73
Giurgola and Mitchell: 68
William H. Grover: 96
Frederick Gutheim, Washington, D. C.: 45
Charles Gwathmey: 74
Haada, *The Lesson of Japanese Architecture:* 20
Hardy, Holzmann and Pfeiffer: 60, 64
Lucien Hervé, Paris: 76
John T. Hill: 113
David Hirsch: 78
Henry-Russell Hitchcock, *Architecture of H. H. Richardson and His Times*,
 Hamden, Conn., 1961: 11
Henry-Russell Hitchcock, *In the Nature of Materials. The Buildings of
 Frank Lloyd Wright, 1887–1941*, New York, 1941: 24, 32
Henry-Russell Hitchcock, *Rhode Island Architecture*, Providence, 1939: 1
Frank Israel: 69
E. J. Jelles and C. A. Alberts, *Duiker 1890–1935*, Amsterdam, 1972: 46
Philip Johnson, courtesy of: 40
Rollin R. La France: 65, 70, 99, 103, 105
Le Corbusier, *Oeuvre Complète*, Zurich, 1964, 1910–1929: 71; 1929–
 1934: 126, 127
Bill Maris: 77
Maris/Semel, courtesy of *House and Garden* © 1972 by the Conde Nast
 Publications, Inc.: 111
James McNeely: 114
Joseph W. Molitor: 47
A Monograph of the Work of McKim, Mead and White, 1879–1915: 110
Charles W. Moore: 48, 50–52, 92
John Naar, 79b